BILL WOODROW

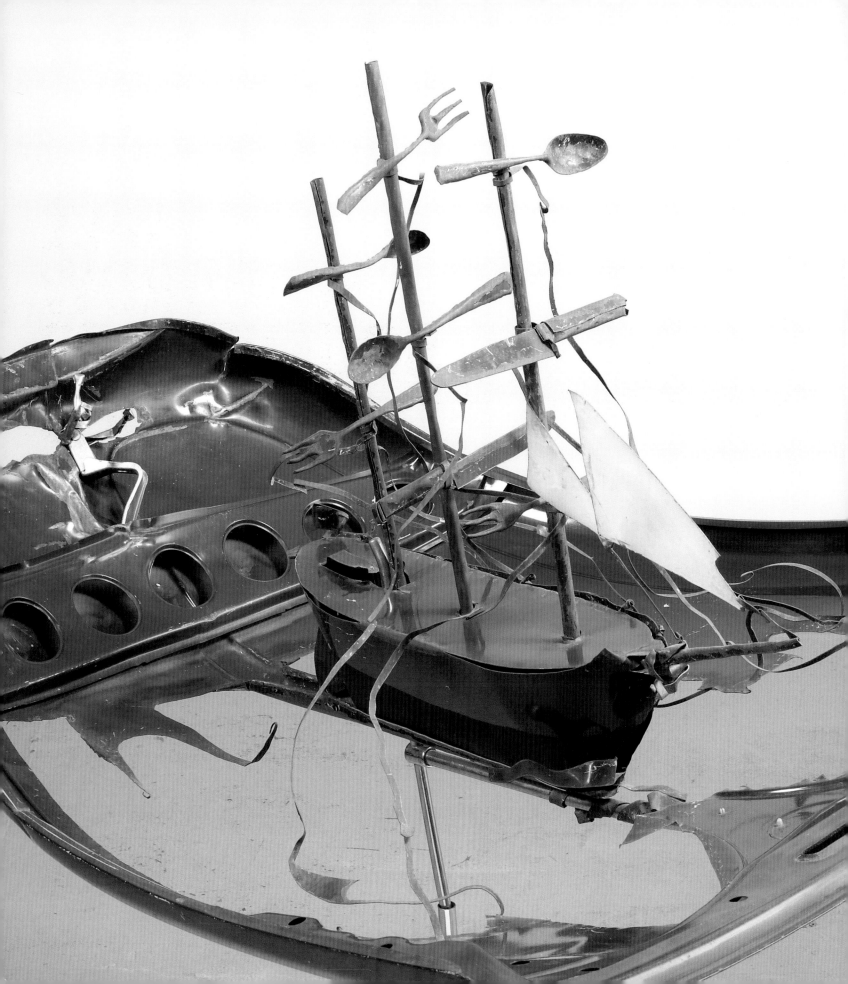

BILL WOODROW SCULPTURES 1981–1988

WADDINGTON CUSTOT GALLERIES 2011

SCULPTURE, *BRICOLAGE* AND THE ART OF BILL WOODROW

Modern and contemporary sculpture has regularly explored the relationships, and exploited the tensions, between found and made objects. The use of found things by artists was once seen primarily as a challenge to artistic skill, replacing the complex processes of making with intellectual acts of choosing and placing. However, such simplistic readings are no longer possible. In recent years, artists have actively questioned these 'found versus made' distinctions as part of a broader revival of interest in ideas of craft and technical artistry. Bill Woodrow's work has a central place in these debates, especially the now-classic 1980s cut-out pieces, which combine the appearance of assemblage with a high degree of manual skill. Woodrow's use of battered-looking domestic objects also today resonates with a contemporary sculptural interest in distressed patinas, awkward and contingent arrangements, an aesthetic of junk-like provisionality. But his technical virtuosity also corresponds to an ongoing commitment amongst younger artists to skill, and to master the means of making sculpture in all their complexities themselves.[1] The conceptual and the manual are combined, as the act of finding or choosing co-exists with the hands-on interventions and manipulations of the artist.

Conceptual and formal aspects of Woodrow's work continue to have a currency among younger artists today. His legacies for contemporary art are diverse, ranging from explicit avowals of influence, found in the statement of the American sculptor Tom Sachs that of the British 'process-oriented' artists of the 1980s, 'Bill Woodrow is a big one', to implicit homages such as Simon Starling's dissections and unravellings of bicycles.[2] In Starling's work the material life of things is examined with Woodrowesque precision, for

instance in *Work Made-Ready, Les Baux de Provence (Mountain Bike)* (2001), where the artist produced a small quantity of aluminium using industrial techniques in order to create a home-made replica of his mass-produced mountain bike. [fig.1] In the recent work of sculptor Clare Barclay, object ensembles and installations that appear to the onlooker to be found are actually made up of carefully handcrafted and manufactured components. The compositions of outmoded consumer goods in Mike Nelson's installations also owe much to Woodrow's influence, as well as Nelson's production of 'home-made' versions of mass-manufactured artefacts like the gun in *Coral Reef* (2000).

To focus on the technical processes and qualities of Woodrow's work might lead us away from some of the stock readings of his 1980s pieces: that they overtly comment on consumer culture (specifically that of Thatcher's Britain), that they suggest the notion of recycling, that they offer a positive recuperation of what society throws away. I don't of course think we can deny these interpretations, as such ideas did have a role to play for the artist and for his audiences, as he has often commented.[3] But the freshness and excitement of these works today lies elsewhere, in their combination of very direct and elegant formal solutions and a more complex negotiation of ways of making art, of grappling with materials and forcing forms and images to co-exist, tenaciously experimenting to see what might happen next.

The immediate predecessors of the early cut-outs were the unfolded bicycle frames of 1980. Like a home science project, Woodrow unravelled bicycle frames as if to see how far they would stretch, reminiscent of childhood tricks like the precise cutting of a small piece of card which

1

1 Simon Starling, *Work Made-Ready, Les Baux de Provence (Mountain Bike)*, 2001, mixed media. © Simon Starling. Collection Tate, London. Photograph © Tate, London, 2011

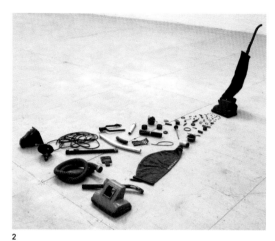

2

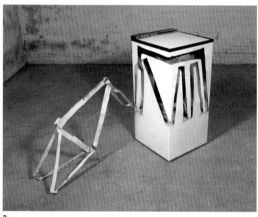

3

2 *Hoover Breakdown*, 1979, upright vacuum cleaner, wooden replica vacuum cleaner, 39 × 61 × 49 in / 100 × 155 × 125 cm
3 *Spin dryer with Bicycle Frame*, 1981, spin dryer, 28¾ × 42⅛ × 19¼ in / 72 × 107 × 49 cm (cat. no.1)

when pulled apart makes a loop large enough to step through. Unlike the 'breakdown' pieces of the late 1970s (such as the famous *Hoover Breakdown*, 1979 [fig.2]), which dismantled everyday objects into an extended array of parts, the bicycle frames achieved a piece of material trickery, making the sturdy steel of the bicycles look pliable and elastic. As such they had more in common with the 'illusions' in Woodrow's earliest art works: polystyrene rocks and photo-sculptural installations with 'floating' twigs. In Woodrow's first cut-out, *Spin dryer with Bicycle Frame* (1981) [fig.3], the bicycle frame is remade, but its image is also present wrapped around the walls of the appliance, rather than laid out on the wall, as previously, as if to see what it would look like circumnavigating the sides of a box. As in the photo-sculptures, a two-dimensional image and a three-dimensional form are set against one another, the resolute flatness of the template space left in the machine playing against both its cubic volume and the new shapes of the metal bicycle.

Woodrow has claimed one of the attractions of the washing machines and other appliances he used was their 'formal qualities'. Their cubic white shapes bring to mind the large lumps of stone to be tackled by the hand of the 'traditional' sculptor: both are measured and formatted units from the quarry or factory. The carving method known as 'direct cutting' finds an apt echo here, the hammers and chisels of the modern artist replaced by Woodrow's metal 'nibblers'. But of course to use found objects suggests an entirely different sculptural lineage. Woodrow's bicycle frames inevitably bring to mind Marcel Duchamp's pseudo-scientific pieces like the *Standard Stoppages* and of course the *Bicycle Wheel* of 1913, where 'experiment' and art work collide.

[fig.4] The *Bicycle Wheel* has of course a two-part composition very much like many of Woodrow's object pairings. Duchamp was also drawn to visual tricks with materials, like the marble 'sugar lumps' in *Why not sneeze?* (1921). Like Duchamp, though, Woodrow is working in dialogue with sculptural tradition, and he is also, especially if recent re-readings of the artisanal properties of Duchamp's readymades are to be believed, pursuing a similar confrontation between mass- and hand-made things, consumer goods imported wholesale and sculptural interventions.[4]

One way of addressing the complexity of Woodrow's 1980s works using found objects would be to call upon the notion of *bricolage*, first outlined by the anthropologist Claude Lévi-Strauss in his book *The Savage Mind* of 1962. One of the reasons for choosing old domestic appliances for Woodrow was their availability on the streets of Brixton in the early 1980s, as people were exchanging such goods for new models. Previously, he had also been using discarded bits of wood and construction materials that had been thrown away. Lévi-Strauss's *bricoleur*, the tinkerer, famously works with what is to hand rather than forging new materials, combining bits and pieces to produce 'a collection of oddments left over from human endeavours'.[5] The *bricoleur* tries out different configurations of things, testing technical solutions, but also allowing the materials themselves to guide a project, which can lead to 'brilliant unforeseen results'.[6] Of course the *bricoleur* cannot be straightforwardly identified with any artist: the starting point of *bricolage* in Lévi-Strauss's theory is the production of functional objects, which become diverted from their original aims and turned into something new. Lévi-Strauss had in mind primarily a conception of non-western

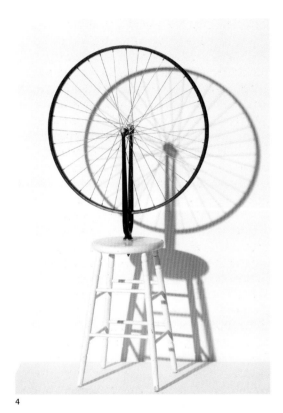

4

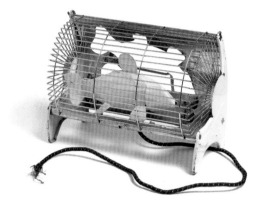

5

held in creative confrontations. In the late 1950s, the anthropologist had conducted a series of radio interviews with the French art critic Georges Charbonnier, in which he discussed the use of the found object by Duchamp, arguing that the readymades needed to have at least two objects, or an object and its original (absent) context in dialogue to produce a 'semantic fission'.[8] 'It is the "sentences" made with objects which have a meaning and not the single object in itself', he claimed.[9]

Woodrow conceives the relationships in his works in a similar binary fashion by using the terminology of the 'host' material and its new object. In his 1980s works, single objects like the washing machines become two objects, one actual, one image, and then two or more objects combine to produce new hybrid offspring. Some of the cut-outs evoke figures of speech: metaphors and similes, adynaton in *Electric Fire with Yellow Fish* (the fish in the fire rather than the water…) [fig.5]. In others narratives or chains of causality are implied, such as the 'incident' series: car leads to gun, chair leads to shooting. Interestingly, some of the original meanings of the term *bricoler* in French described the rebounding movements and ricochets of billiard and ball games, a causal sequence where the final outcome is unintended, surprising, perhaps unsettling. The poetic term employed by one curator to describe the connections between the elements of his work - 'umbilical chords'[10] - uses a metaphor which, as well as connoting maternal bonds, suggests musical harmony, and the motif of musical instruments in his work (rendered as hollow steel boxes of differing scales) brings to mind 'resonances' both literal and figurative.[11] But the overriding impression of the cut-out works

technological thinking, which, he was attempting to suggest, was closer in spirit to western culture than had previously been imagined. If the *bricoleur* is thus pitted against the figure of the scientist-engineer, the artist lies somewhere in between, partaking of both 'scientific knowledge and mythical or magical thought'.[7]

Lévi-Strauss's highly suggestive comments on an imagined mode of 'concrete' thinking in non-western cultures (from our perspective now we could read this only as a western projection and not as a workable model for the cultures involved), evoked a coming together of heterogeneous things,

4 Marcel Duchamp, Roue de bicyclette (*Bicycle Wheel*), 1913/1964, a bicycle wheel assembled onto a stool, metal and painted wood, 50 × 12 × 25 in / 126·5 × 31·5 × 63·5 cm AM1986-286 © Succession Marcel Duchamp / ADAGP, Paris and Dacs, London, Collection musée national d'Art moderne - Centre Georges Pompidou, Paris © Collection Centre Pompidou, Dist. RMN / Philippe Migeat
5 *Electric Fire with Yellow Fish*, 1981, electric fire, enamel and acrylic paint, 10⅝ × 14⅝ × 7½ in / 27 × 37 × 19 cm (cat. no.4)

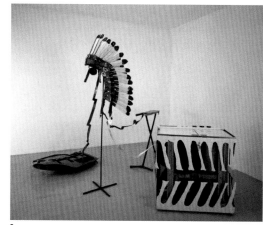

6

ultimately is one of creative dissonance, of a clash of worlds and realms, juxtaposed materials and concepts.

In her insightful essay on the artist of 1986, Lynne Cooke described his approach as having something in common with anthropology. For her, Woodrow adopted 'an ethnologist's view-point' through his focus on material artefacts that could shed light on the human values and relationships of their cultures of origin.[12] In a series of works in 1981–82, Woodrow referred explicitly to non-western artefacts, a North West Coast American headdress and three African masks. In the first of these, *Car Door, Ironing Board and Twin-tub with North American Indian Headdress*, the artist was inspired by a toy headdress belonging to his children, rather than any specific artefact, but was very struck by the different values acquired by an object of this kind as it travelled from its original culture to the western museum and then was remade as a child's plaything. [fig.6] As he has pointed out, he himself had never encountered such a headdress in its original setting.[13] The

formal device of the stand in the work served to underline the 'museumified' aspect of the headdress, an effect Woodrow sought to repeat in the three related works using African masks: *Armchair, Washing Machine and Kurumba Mask*; *Washing Machine, Armchair and Car Bonnet with Bena Biombo Mask*; and *Armchair and Washing Machine with Bobo Mask* (all 1982). [figs.7, 8, 9]

Like many of Woodrow's 1980s pieces, these works bring together a heady and overlapping mix of references and iconographies. The natural materials of the headdress and masks: feathers, fabric, wood and raffia, are rendered through the 'modern' (and 'unnatural') steel and leatherette of western industry. This interplay between the natural world and its living, organic textures and the smooth standardised surfaces and formatted units of mass manufacturing is present in many of the works of this period, particularly those involving representations of animals: the shiny wet scales of the fish, the smooth fur of the beaver, the rough skin of the elephant. Two of the African masks that Woodrow refers to are depictions of animal spirits:

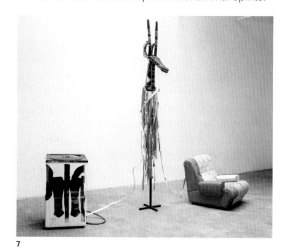

7

6 *Car Door, Ironing Board and Twin-tub with North American Indian Headdress*, 1981, car door, ironing board, washing machine, enamel paint, 73 × 111 × 62 in / 186·5 × 283 × 157 cm. Collection Tate, London
7 *Armchair, Washing Machine and Kurumba Mask*, 1982, armchair, washing machine, metal stand, enamel paint, 95 × 158 × 79 in / 240 × 400 × 200 cm

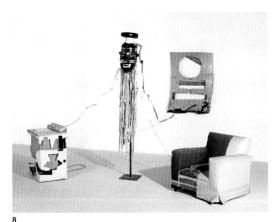

8

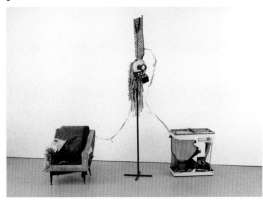

9

the Kurumba antelope mask (the antelope is the protective ancestral totem); and the Bobo rooster mask (a fecundity spirit). The original versions of masks like these are themselves made of a mix of media: wood, paint and raffia extensions (which ironically given Woodrow's museum-type displays comparatively rarely survive in museum examples of these kinds of masks). Woodrow echoes this combination of different materials by bringing together hard metal for the 'wood' of the mask, and soft plasticated fabric for the raffia costume. As if

he is making a kind of home-made homage, using the humble washing machine and the sad old armchair, Woodrow emulates the virtuosity of the original African mask in his own skilful rendering of its formal and textural interplays. The *bricoleur*, of course, is aligned by Lévi-Strauss with the figure of the amateur in its positive sense: one who has an intense devotion to the things he tinkers with and is dedicated to the precise details of their realisation. Mary Jane Jacob has written that Woodrow 'often makes things that he himself would like to have'.[14]

The kinds of African artefacts chosen by Woodrow as his starting points have in common their use of relatively lightweight mixed materials, given their function as things to be worn and danced with. It seems significant, for instance, that he did not choose to depict statuettes, or so-called power figures. We sense he was drawn to the formal possibilities of these masks with their 'grass' costumes on stands, and also perhaps to the resonances between the fragile raffia and the obsolete consumer goods he had cut into. Masks of this nature in their original contexts were often never meant to be preserved, having served their ceremonial purpose, and as such their 'meaning' for their cultures resided not primarily in the objects themselves, but in a network of events and interactions: the processes of their manufacture; their selection and sacredness (often enhanced through extra ceremonies); and of course their animation through their human wearers. In these pieces, there is a strong sense of tension between the inanimate domestic objects and the 'animate' presence suggested by the mask, which stands on display as if held aloft by the absent bearer. Is this the revenge of the non-western cultures, here presiding over, and rising phoenix-like from the

8 *Washing Machine, Armchair and Car Bonnet with Bena Biombo Mask*, 1982, washing machine, armchair, car bonnet, enamel and acrylic paint, 87 × 122 × 126 in / 220 × 310 × 320 cm
9 *Armchair and Washing Machine with Bobo Mask*, 1982, armchair, washing machine, acrylic paint, height c.118 in / c.300 cm, width variable, (cat. no.7)

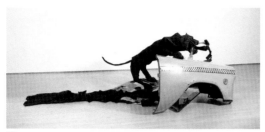

10

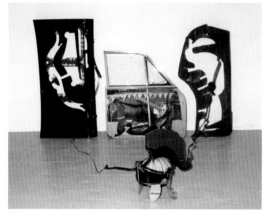

11

10 *Tattoo*, 1983, car door, car panel, cloth, 42½ × 110¼ × 96⅛ in / 108 × 280 × 244 cm (cat. no.11)
11 *Car Door, Boot and Wing with Roman Helmet*, 1982, car door, boot and wing, 69 × 98 in / 175 × 250 cm
12 Marcel Broodthaers, *Atlas*, 1975, relief print on paper, 19 × 25 in / 48·5 × 63 cm. © DACS 2011. Collection Tate, London. Photograph © Tate, London, 2011

debris of, a corrupted west? In some of Woodrow's animal works, for instance *Tattoo* (1983), there is a similar evocation of the payback exacted by a slighted natural world. [fig.10] A very different effect is achieved in two pieces depicting Roman helmets (*Car Doors and Paraffin Heater with Roman Helmet* and *Car Door, Boot and Wing with Roman Helmet*, both 1982), where the 'grounded' helmets are on a level with, or physically lower than the modern objects that spawn them. [fig.11]

Woodrow of course was always very conscious of the attraction of the 'exotic', and how he himself was very drawn to non-western artefacts of this kind as something western culture had 'lost'. His 1980s works were produced in the context of a growing international interest in the resonances between art works from different cultures and indeed the problems that these kinds of comparisons could entail, as witnessed in the debates that arose in the wake of the Museum of Modern Art's 1984 exhibition *"Primitivism" in Twentieth-Century Art: Affinity of the Tribal and the Modern*. When the Pompidou Centre in Paris mounted a riposte to this in 1989, *Les Magiciens de la terre*, bringing together contemporary artists from all parts of the globe, its curators were already more careful to include ironic commentaries on the construction of the exotic, such as Marcel Broodthaers *Atlas* of 1975. [fig.12]

In Woodrow's later 1980s work *Madagascar* (1987), he included a framed painting representing his imaginary view of an island which fascinated him but which he had never visited.[15] [fig.13] Images evoking the 'essence' of Madagascar – the chameleons that are one of its well-known inhabitants, and the red splash of the blood-letting of the famous Malgasy Zebu cattle – are juxtaposed with a branch hewn by

12

a machete, suggesting the destruction of native habitat and the loss of tradition and identity. But this reading is made ambivalent by the deliberately vague 'oriental-style' carpet that supports the composition, itself painted to form a frame with a blank, white centre: a formal device, but also a reminder of the gaping hole of knowledge onto which western ideas can be projected. In this piece from the later 1980s, the source of the steel, a metal locker, is no longer explicitly present, but the same kinds of contrasts of materials and textures, organic and inorganic, soft and hard, rough and smooth, are at play, while the chameleon seems to additionally point to the ability of the steel itself, in Woodrow's capable hands, of metamorphosing in changing contexts.

It is clear that Woodrow was fully aware in such 'anthropological' works of the ambivalences of his position. The tensions and contradictions between 'self' and 'other' were also present in the sculptures themselves. From a contemporary perspective, Woodrow's recreations of masks using western goods also, for instance, inevitably bring to mind the 'hybrid' art made particularly in Africa

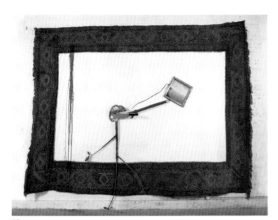

13

using discarded colonial artefacts: the 'throne of weapons' made by the Mozambique artist Kester being a famous example. [fig.14] Such works troubled the notion that non-western artistic production was somehow 'pure' and 'untainted' by outside cultural influences, and brought another dimension to the re-use of the obsolete consumer item by challenging the power structures that they embodied. In Michel de Certeau's *Practice of Everyday Life*, first published in 1974, this kind of appropriation is what he calls a 'tactical' form of consumption, part of a series of little ruses and manipulations that together make up a crucial way of operating within the dominant culture. *Bricolage*, for him an 'artisan-like inventiveness', is another of these modes of operating, along with many everyday domestic activities such as shopping and cooking.[16]

Certeau's conception of the everyday has been highly influential for contemporary art, not least in its empowerment of makeshift, provisional and experimental gestures. But it is also striking in its cross-cultural remit, given Certeau's background as anthropologist (and indebtedness to other

anthropologists like Lévi-Strauss). Woodrow's sculptures based on African masks, as we have seen, are part of a wider current in his practice that addresses confrontations between cultures and is still ongoing today. Some of his 1980s works which took the form of larger groupings of objects or installations, such as *Life on Earth* (1983), *Elephant* (1984), and the Documenta piece *The Lure of Civilization* (1987), in their complex negotiation of concepts of the exotic and the global via found materials, pre-figure the installations and work of many contemporary artists in this mode. [fig.15]

But Woodrow's manipulations can also be strikingly simple: cutting into an old bean can or a saucepan, a twist and turn of a pan or spoon to make a bird or a face. [figs.16, 17] The richness of his work lies in this dynamic interplay between small gestures and larger meanings, as well

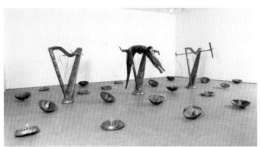

15

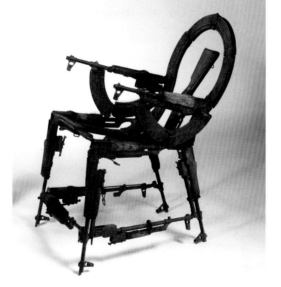

14

13 *Madagascar*, 1987, carpet, metal locker, acrylic paint, 118 × 149⅝ × 10 in / 300 × 380 × 25 cm (cat. no.19)
14 Kester, *Chair*, c.2000, dismantled weapons, 36 × 21 × 29 in / 92 × 53·5 × 74 cm. © The Artist. Collection The Royal Armouries Museum, Leeds. © Board of Trustees of the Armouries
15 *The Lure of Civilization*, 1987, copper water cylinders, enamel paint, 158 × 472 × 91 in / 400 × 1200 × 230 cm

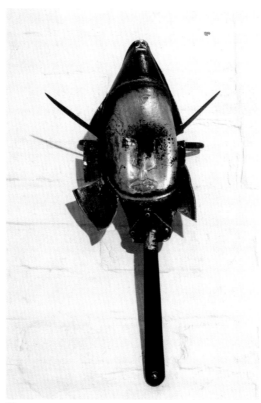

16

17

as between finding and making. It is also to be found, by extension, in the ways in which layers of references, concepts and images are conjured from such interactions with his chosen materials. There is a fascinating dialectic at play here. On the one hand, looking across Woodrow's cut-outs, we find him taking on important themes with an allegorical repertoire that would extend with increasing sophistication into the 1990s and beyond. And yet, on the other hand, we also find him eschewing definitive statements, and in the light of the skilful activities of the *bricoleur*

and what Certeau calls 'poetic ways of "making-do"'[17], drawing unexpected insights from everyday objects and asking that we, in turn, think again about the potential meanings and forms of things, interrogating their surfaces and depths.

JULIA KELLY

16 *African Head*, 1983, frying pan, scissors
17 *Pan Head 2*, 1985, pan, 9 × 2 × 3 in / 23 × 6 × 7 cm

ENDNOTES

1 See Jon Wood, 'Knots, Rope Tricks and Other Manual Thoughts', *Oscillator, Bill Woodrow: New Sculpture and Painting*, Waddington Galleries, London, 2008, pp.41–47

2 'Tom Sachs by Jon Kessler', *BOMB* 83/Spring 2003, np, www.bombsite.com/issues/83/articles/2544 (accessed 3/1/11)

3 See for instance 'Bill Woodrow interviewed by Keith Patrick' (unpublished interview of 1996), www.billwoodrow.com/dev/texts (accessed 12/1/11)

4 See Rhonda Roland Shearer, 'Marcel Duchamp's Impossible Bed and Other "Not" Readymade Objects: A Possible Route of Influence from Art to Science', Part 1, *Art and Academe* 10, no.1 (Fall 1997), pp.26–62

5 Claude Lévi-Strauss, *The Savage Mind* [1962], trans. John and Doreen Weightman, Weidenfeld and Nicolson, London, 1966, p.19

6 Lévi-Strauss, *Savage Mind*, p.17

7 Lévi-Strauss, *Savage Mind*, p.22

8 Georges Charbonnier, *Conversations with Claude Lévi-Strauss* [1961], trans. John and Doreen Weightman, Cape, London, 1969, p.92

9 Charbonnier, *Conversations with Claude Lévi-Strauss*, p.95

10 Catherine Grenier, 'Fables & Truths, Bill Woodrow Sculptures 1987–1989', in *Bill Woodrow: Eye of the Needle*, Musée des Beaux-Arts, Le Havre, 1989, np.

11 The 2004 exhibition *With Hidden Noise* brought together Duchamp's eponymous object of 1916 with Woodrow's *Songs of Praise* (1983), *With Hidden Noise: Sculpture, Video, Ventriloquism*, Henry Moore Institute, Leeds, 2004

12 Lynne Cooke, 'The Elevation of the Host', *Bill Woodrow*, Fruitmarket, Edinburgh, 1986, p.1

13 These remarks are based on a conversation with the artist, 9 January 2011

14 Mary Jane Jacob, 'Bill Woodrow: Objects Reincarnated' in *A Quiet Revolution, British Sculpture since 1965* (ed. Terry A. Neff), Thames and Hudson, London, 1987, p.162

15 The remarks in this paragraph are based on a conversation with the artist, 9 January 2011

16 Michel de Certeau, *The Practice of Everyday Life* [1974], trans. Steven Rendall, University of California Press, Berkeley and London, 1988, p.xviii

17 Certeau, *Practice of Everyday Life*, p.xv

1

Spin dryer with Bicycle Frame
1981
spin dryer
28⅜ × 42⅛ × 19¼ in / 72 × 107 × 49 cm

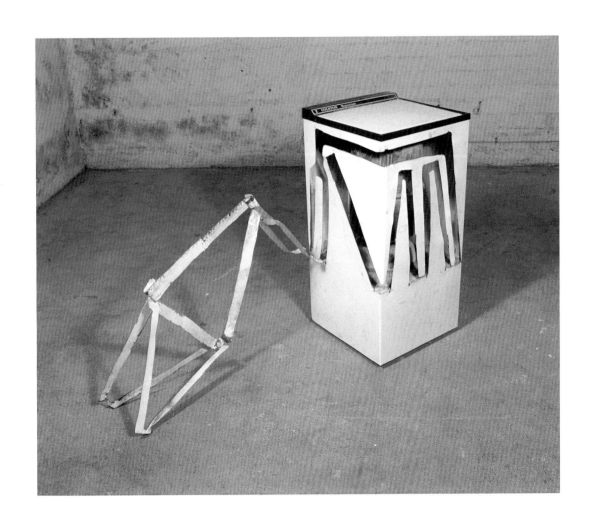

2

Spin dryer with Bicycle Frame including Handlebars
1981
spin dryer
26⅜ × 42⅛ × 25¼ in / 67 × 107 × 64 cm

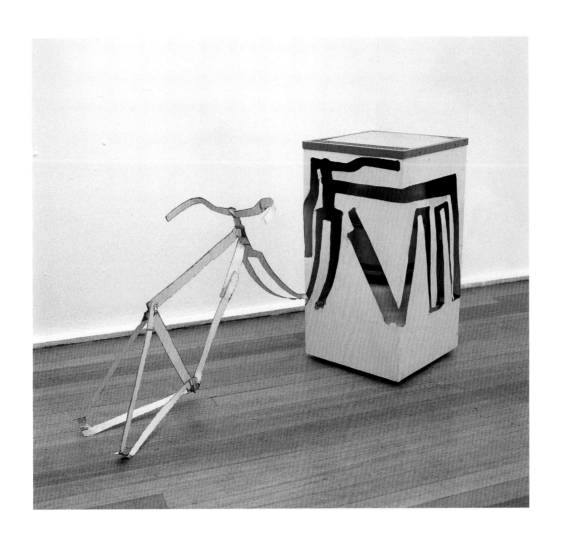

3

The Red Hat
1981
spin dryer, hat, enamel paint
30½ × 34½ × 46 in / 77·5 × 88 × 117 cm

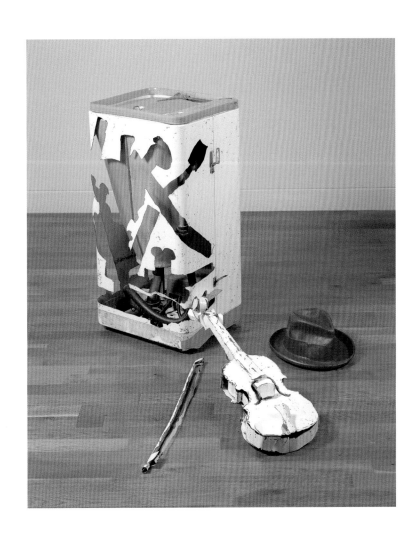

4

Electric Fire with Yellow Fish
1981
electric fire, enamel and acrylic paint
$10\frac{5}{8} \times 14\frac{5}{8} \times 7\frac{1}{2}$ in / 27 × 37 × 19 cm

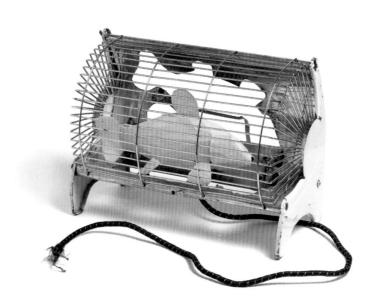

5

Car Door, Armchair and Incident
1981
car door, armchair, enamel paint
47¼ × 118⅛ × 118⅛ in / 120 × 300 × 300 cm

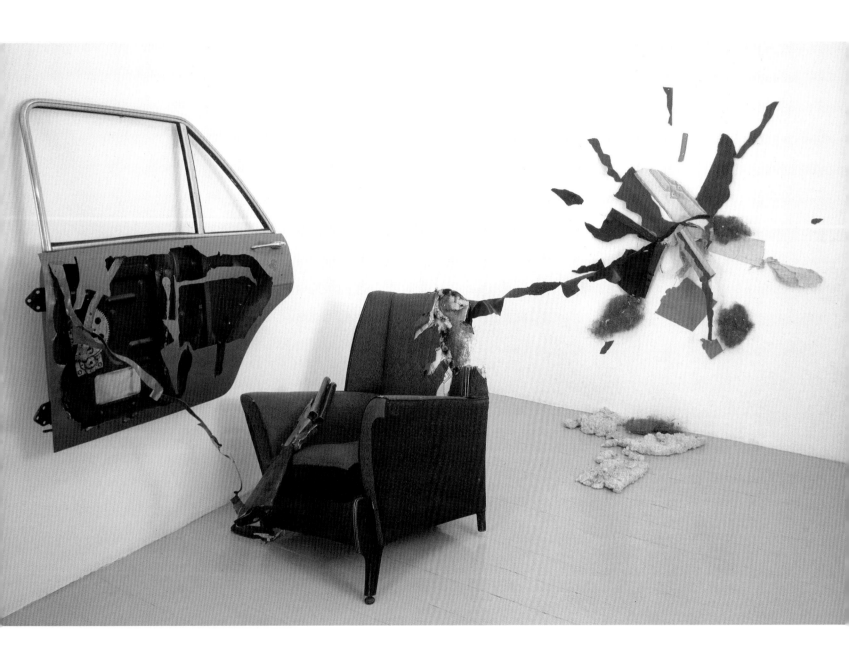

6

Bean Can with Spectacles
1981
tin can, acrylic paint
4½ × 8¾ × 6½ in / 11·5 × 22 × 16·5 cm

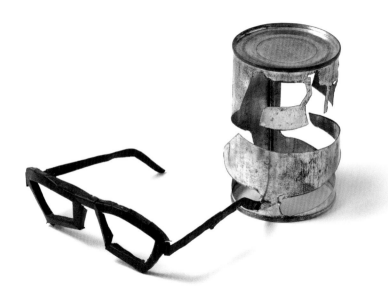

7

Armchair and Washing Machine with Bobo Mask
1982
armchair, washing machine, acrylic paint
height c.118 in / c.300 cm, width variable

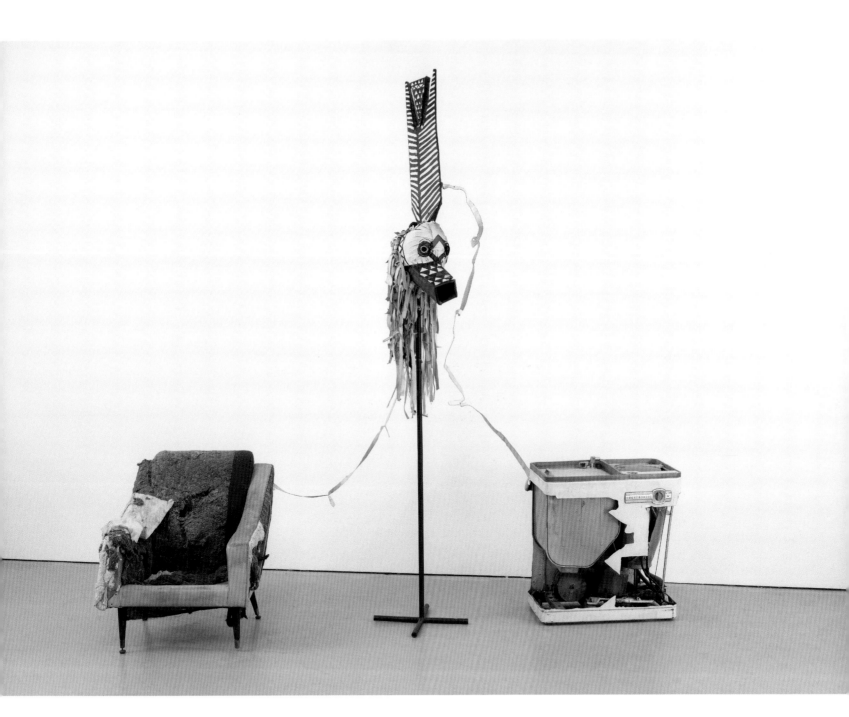

8

A Passing Car, a Caring Word
1982
bed base, car door, enamel paint
118 × 78¾ × 102⅜ in / 300 × 200 × 260 cm approx.

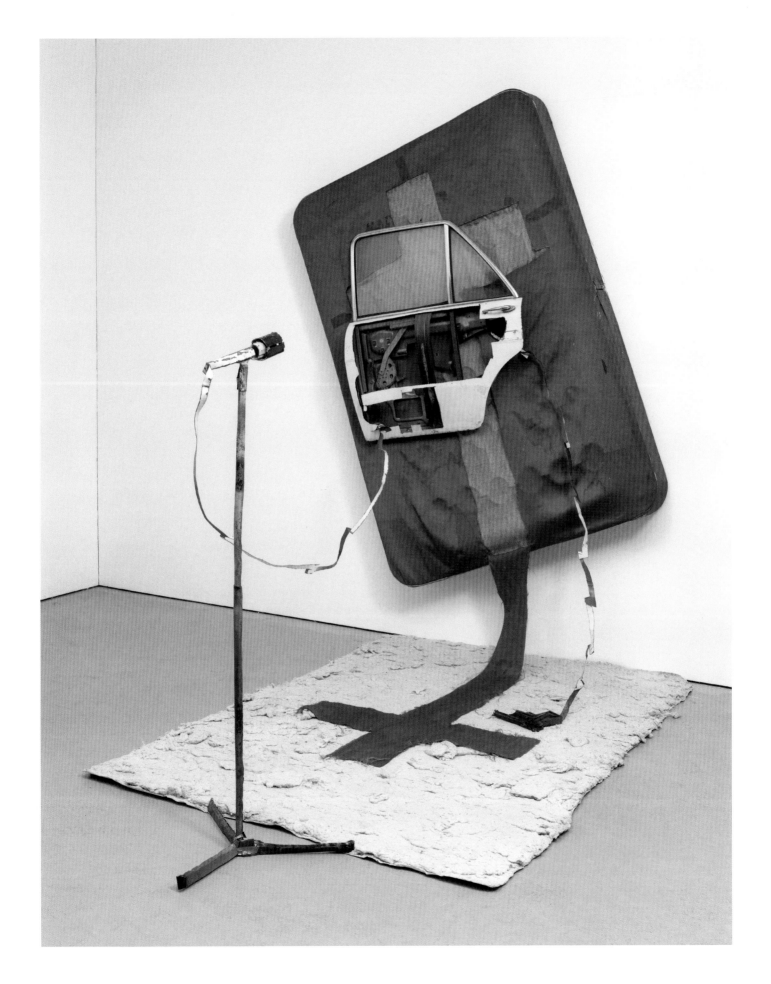

9

Humming Bird, Ring and Medal
1982
car door, enamel and acrylic paint
25½ × 35½ × 11 in / 65 × 90 × 28 cm

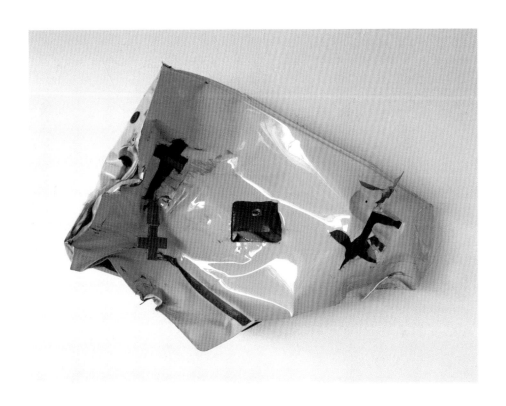

10

Soupe du Jour
1983
saucepan and ladle, enamel paint
$11 \times 15\frac{3}{8} \times 8\frac{5}{8}$ in / $28 \times 39 \times 22$ cm

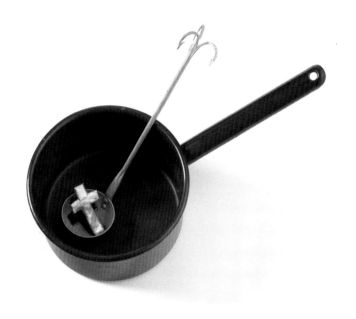

11

Tattoo
1983
car door, car panel, cloth
42½ × 110¼ × 96⅛ in / 108 × 280 × 244 cm

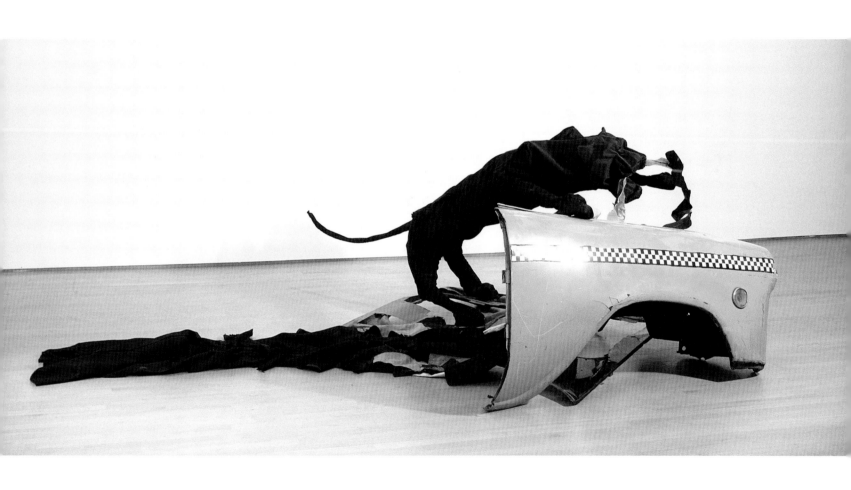

12

Ship of Fools, Figure of Gold
1984
car bonnet, chrome stand, enamel paint
67 × 46½ × 55 in / 170 × 118 × 140 cm

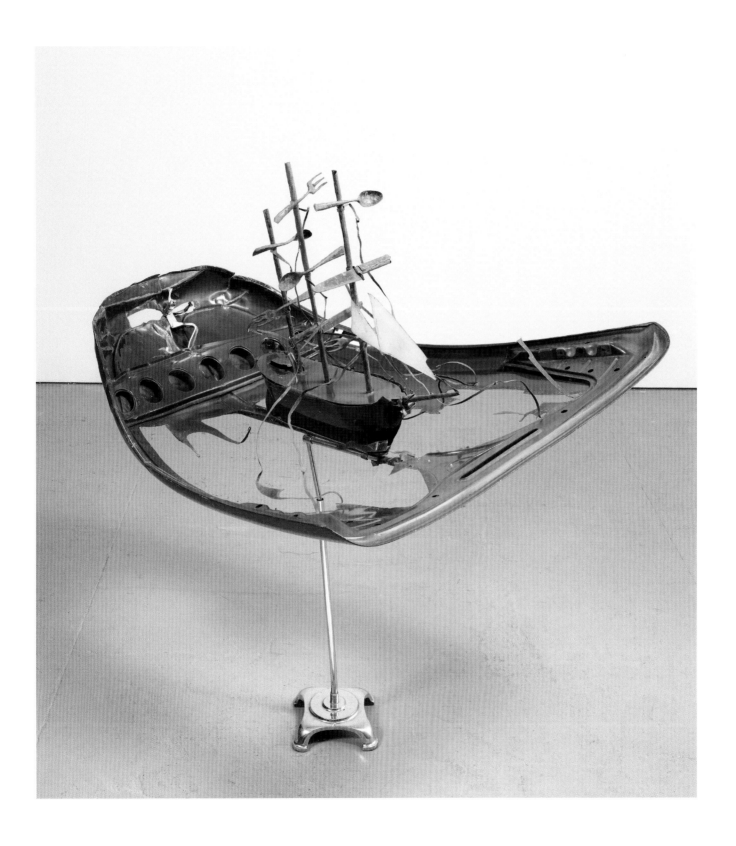

13

Flageolet Plate
1984
telephone relay box, enamel paint
39⅜ × 15¾ × 15¾ in / 100 × 40 × 40 cm

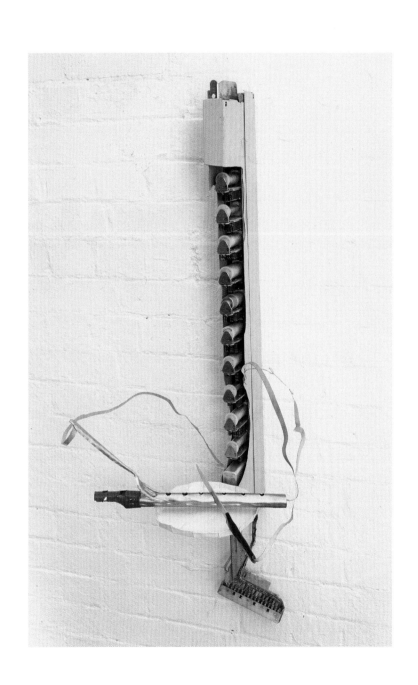

14

Sunset
1984
car bonnet, wooden table, enamel paint
68½ × 51 × 25½ in / 174 × 130 × 65 cm

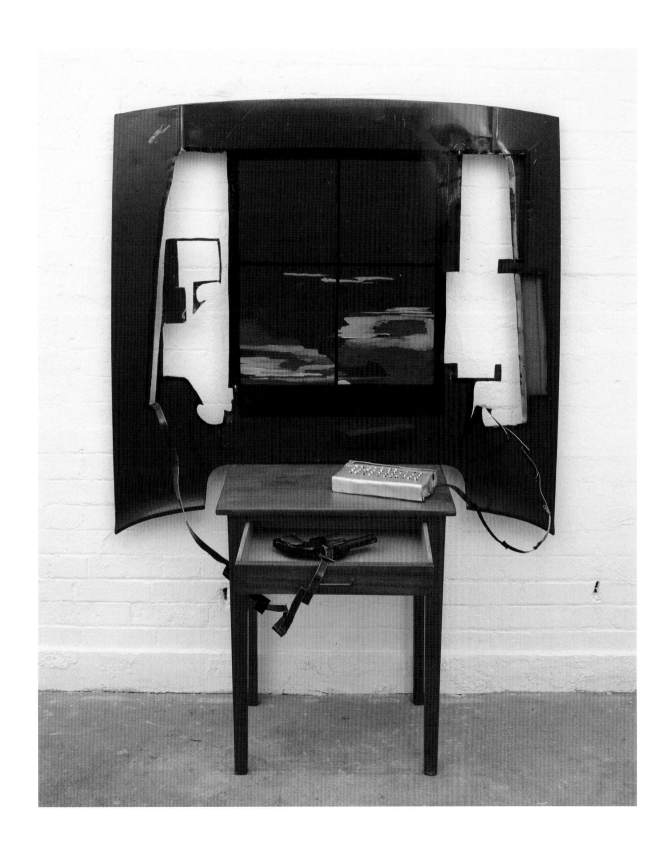

15

Closet
1985
metal locker, enamel paint
69 × 27 × 55½ in / 175 × 69 × 141 cm

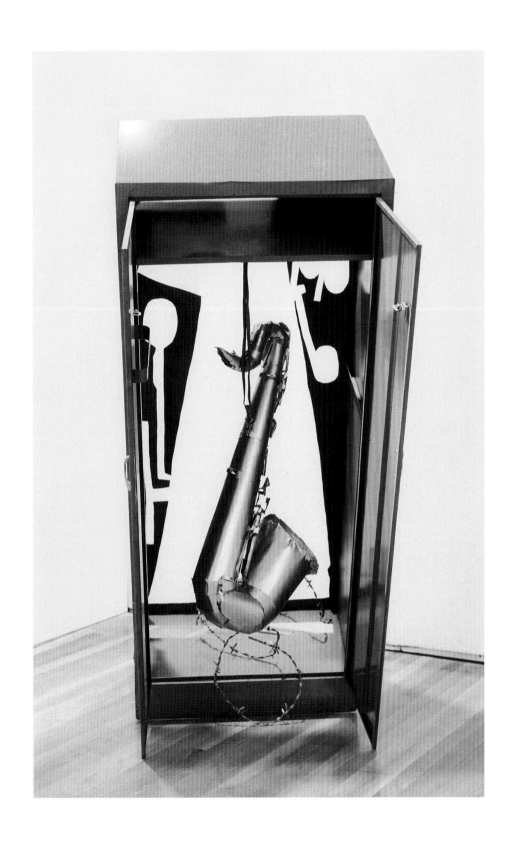

16

Hammer On
1987
metal suitcase, enamel paint
46½ × 18 × 10¼ in / 118 × 46 × 26 cm

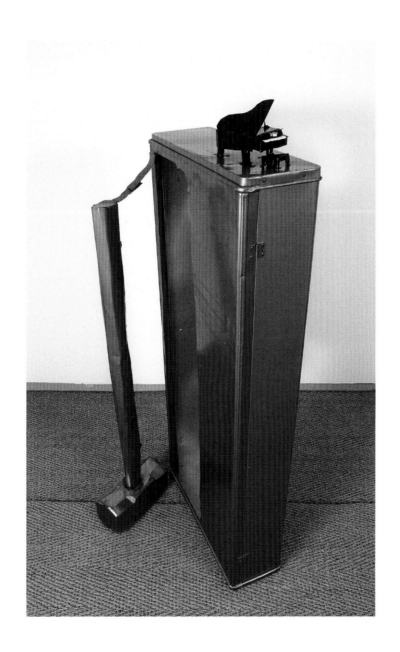

17

Silent Running
1987
ventilation ducting, desk trays, wooden barrel, enamel paint
51½ × 42 × 27 in / 131 × 107 × 69 cm

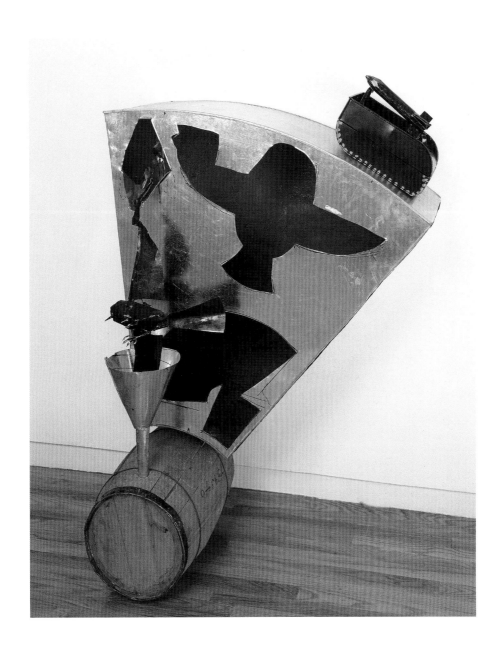

18

Half King, Whole Fish
1988
car bonnet, steel locker, metal hat box, aluminium ladder, chair, enamel paint
87 × 55 × 30¾ in / 221 × 140 × 78 cm

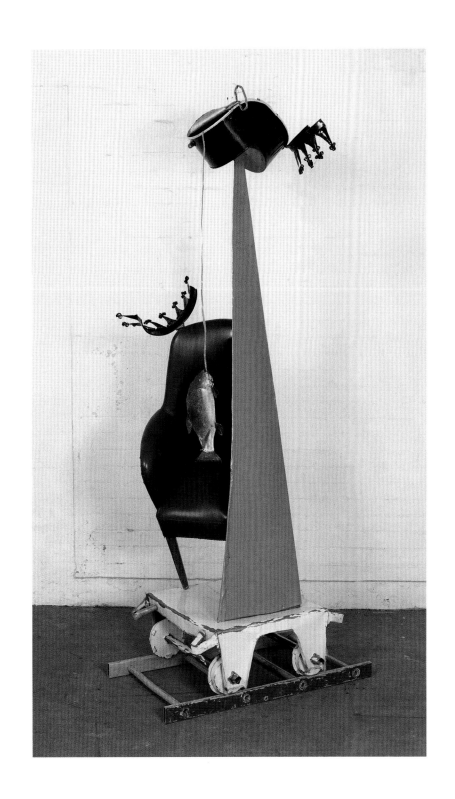

19

Madagascar
1987
carpet, metal locker, acrylic paint
$118 \times 149\frac{5}{8} \times 10$ in / $300 \times 380 \times 25$ cm

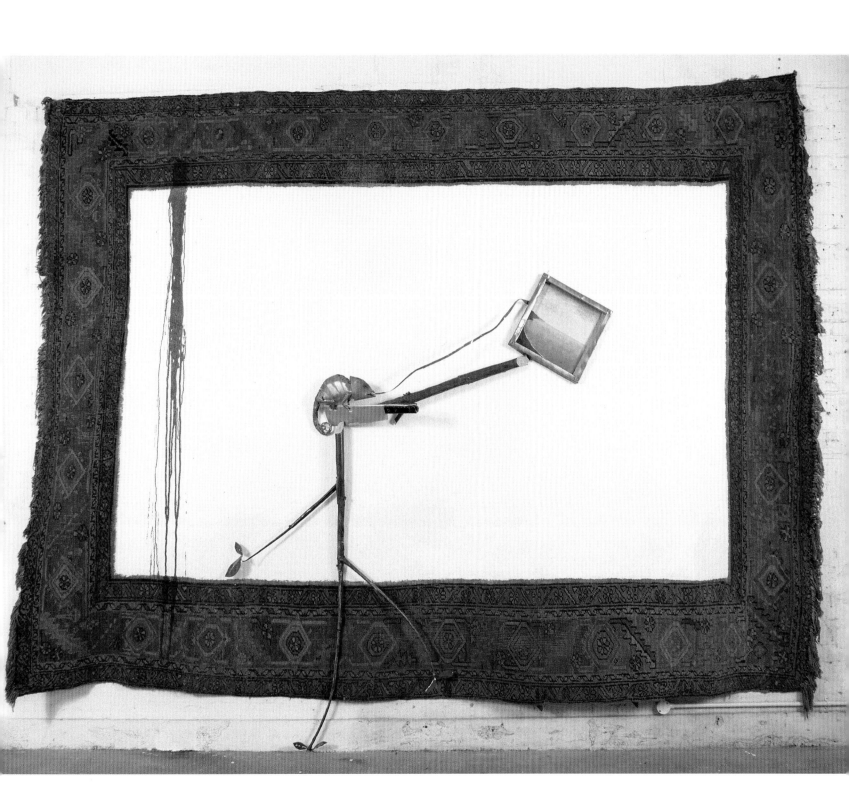

1
Spin dryer with Bicycle Frame
1981
spin dryer
28⅜ × 42⅛ × 19¼ in / 72 × 107 × 49 cm

Provenance
The artist

2
Spin dryer with Bicycle Frame including Handlebars
1981
spin dryer
26⅜ × 42⅛ × 25¼ in / 67 × 107 × 64 cm

Provenance
The artist

Exhibited
'Objects & Sculpture', Arnolfini Gallery, Bristol, 23 May–
20 June 1981, and Institute of Contemporary Arts,
London, 10 July–9 August 1981 (ex-catalogue)
'Bill Woodrow: Sculpture', New 57 Gallery, Edinburgh,
10–31 October 1981
'Englische Plastik Heute / British Sculpture Now:
Stephen Cox, Tony Cragg, Richard Deacon, Anish
Kapoor, Bill Woodrow', Kunstmuseum Luzern,
Lucerne, Switzerland, 11 July–12 September 1982
(ex-catalogue)

Literature
Bill Woodrow (exhibition catalogue), Galerie Wittenbrink,
Regensburg, Germany, 1981 (repro.)
'Between Image and Object: The "New British
Sculpture"', Lynne Cooke, in *A Quiet Revolution:
British Sculpture Since 1965* (exhibition catalogue),
Thames and Hudson, London, 1987, pp.34–53, cit.
pp.38 & 42 (repro. in b&w p.166, pl.113)
'Bill Woodrow: Objects Reincarnated', Mary Jane Jacob,
in *A Quiet Revolution: British Sculpture Since 1965*
(exhibition catalogue), Thames and Hudson, London,
1987, pp.156–162, cit. p.160 (repro. in b&w p.166,
pl.113)
Bill Woodrow: Brood (exhibition catalogue), Hampshire
County Council, Winchester, 2007 (repro. in colour p.19)

3
The Red Hat
1981
spin dryer, hat, enamel paint
30½ × 34½ × 46 in / 77·5 × 88 × 117 cm

Provenance
The artist
Lisson Gallery, London
Private Collection, Germany
New Art Centre Sculpture Park & Gallery, Roche Court

Exhibited
'Bill Woodrow: Sculpture', Galerie Wittenbrink,
Regensburg, Germany, 5 December 1981–20 January
1982
'Bill Woodrow: Sculpture', Kunstausstellungen, Stuttgart,
20 March–24 April 1982
'Bill Woodrow', Galerie 't Venster, Rotterdam, 8
October–10 November 1982 (repro. in b&w in
catalogue p.5)
New Art Centre Sculpture Park & Gallery, Roche Court,
East Winterslow, Salisbury, 2004

Literature
Neue Skulptur (exhibition catalogue), Patrick Frey and
Helmut Draxler, Galerie nächst St. Stephan, Vienna,
1982 (repro.)
Arcaico Contemporaneo (exhibition catalogue), Enrico
R. Comi, Museo del Sannio-Benevento / The British
Council, 1983 (repro. in b&w p.89)
Bill Woodrow, Waddington Galleries, London, 2005
(repro. in colour p.[17])

4
Electric Fire with Yellow Fish
1981
electric fire, enamel and acrylic paint
10⅝ × 14⅝ × 7½ in / 27 × 37 × 19 cm

Provenance
The artist

Exhibited
'Transformações: Nova Escultura da Grã Bretanha / Transformations: New Sculpture from Britain', British Council exhibition, XVII Bienal de São Paulo, São Paulo, 14 October–18 December 1983; touring to Museu de Arte Moderna, Rio de Janeiro, 20 January–20 February 1984; Museo de Arte Moderno, Mexico City, 15 March–27 May 1984; Fundação Calouste Gulbenkian, Lisbon, 28 June–12 August 1984 (repro. in b&w in catalogue p.67)
'No Place Like Home', Cornerhouse, Manchester, 29 November 1986–18 January 1987
'Un siècle de sculpture anglaise', Galerie nationale du Jeu de Paume, Paris, 6 June–15 September 1996 (repro. in colour in catalogue p.315)
'Field Day: Sculpture from Britain', organised in collaboration with The British Council, Taipei Fine Arts Museum, Taipei, 7 April–24 June 2001 (repro. in colour in catalogue p.65)
'Turning Points: 20th Century British Sculpture', organised in collaboration with The British Council, Tehran Museum of Contemporary Art, Tehran, 24 February–16 April 2004 (repro. in colour in catalogue p.61)
'Sculpture', Waddington Galleries, London, 5–30 October 2010 (repro. in colour in catalogue)
'Modern British Sculpture', Royal Academy of Arts, London, 22 January–7 April 2011, catalogue no.111 (repro. in colour p.252)

Literature
Objects & Figures (exhibition broadsheet), Fruitmarket Gallery, Edinburgh, 1982 (repro. in b&w)
'Martian poets', *Artics*, no.1, Barcelona, July 1985 (repro.)
Bill Woodrow: Sculpture 1980–86 (exhibition catalogue), Lynne Cooke (intro.), The Fruitmarket Gallery, Edinburgh, 1986, p.28 (repro. in colour p.[29])
'Between Image and Object: The "New British Sculpture"', Lynne Cooke, in *A Quiet Revolution: British Sculpture Since 1965* (exhibition catalogue), Thames and Hudson, London, 1987, pp.34–53, cit. p.48 (not repro.)
'Bill Woodrow: Fables et vérités', Catherine Grenier, *Artstudio* 10, Autumn 1988, pp.[80]–87, cit. p.83 (not repro.)
Skulptur: Prekärer Realismus zwischen Melancholie und Komik (exhibition catalogue), Kunsthalle Wien, Vienna, 2004 (repro. in colour p.174)
'Best of British: A Century of Sculpture in Academy Show', *The Daily Telegraph*, London, 9 September 2010 (repro. in colour p.12)

5
Car Door, Armchair and Incident
1981
car door, armchair, enamel paint
47¼ × 118⅛ × 118⅛ in / 120 × 300 × 300 cm

Provenance
The artist

Exhibited
'Bill Woodrow', Lisson Gallery, London, 14 January–13 February 1982
'Bill Woodrow: Sculpture', St. Paul's Gallery, Leeds, 27 April–14 May 1982
'XII Biennale de Paris', Palais de Tokyo, Musée d'Art Moderne, Paris, 2 October–14 November 1982
'Bill Woodrow: Beaver, Bomb and Fossil', Museum of Modern Art, Oxford, 29 May–31 July 1983, catalogue no.12 (repro. in colour p.8)
'The British Show', organised in collaboration with The British Council, Art Gallery of Western Australia, Perth, 19 February–24 March 1985; touring to Art Gallery of New South Wales, Sydney, 23 April–9 June 1985; Queensland Art Gallery, Brisbane, 5 July–11 August 1985; Royal Exhibition Hall, Melbourne, 26 September–5 November 1985; National Art Gallery, Wellington, New Zealand, 5 December 1985–26 January 1986, catalogue p.160 (repro. in colour p.128)
'Starlit Waters: British Sculpture, An International Art 1968–1988', Tate Gallery, Liverpool, 28 May–4 September 1988, catalogue no.54 (repro. in colour p.32)
'Field Day: Sculpture from Britain', organised in collaboration with The British Council, Taipei Fine Arts Museum, Taipei, 7 April–24 June 2001 (repro. in colour in catalogue p.64)
'Punk. No One is Innocent', Kunsthalle Wien, Vienna, 16 May–7 September 2008 (repro. in colour in catalogue pp.[74–75])

Literature

'The sculpture of Bill Woodrow', David Elliott, in *Bill Woodrow: Beaver, Bomb and Fossil* (exhibition catalogue), Museum of Modern Art, Oxford, 1983, pp.3–10, cit. p.6

Bill Woodrow: Sculpture 1980–86 (exhibition catalogue), Lynne Cooke (intro.), The Fruitmarket Gallery, Edinburgh, 1986, p.36 (repro. in colour p.[37])

'Bill Woodrow: Fables et vérités', Catherine Grenier, *Artstudio* 10, Autumn 1988, pp.[80]–87, cit. p.84 (not repro.)

'Nova britanska skulptura', M. Prodanovic ed., *Moment* 15, Gornji Milanovac, Serbia, July–September 1989 (repro. in b&w p.3)

'The Sculpture of Bill Woodrow: Casting between the Currents', John Roberts, in *Bill Woodrow: Fools' Gold* (exhibition catalogue), Tate Publishing, London, 1996, pp.9–32, cit. p.19 (not repro.)

Modern Art: A Very Short Introduction, David Cottington, Oxford University Press, Oxford, 2005, p.104 (repro. in b&w fig.18)

Sculpture, Waddington Galleries, London, 2007, no.37 (repro. in colour p.75)

6
Bean Can with Spectacles
1981
tin can, acrylic paint
4½ × 8¾ × 6½ in / 11·5 × 22 × 16·5 cm

Provenance
The artist

Exhibited
'Barely Made', Norwich Gallery, Norwich, 5 March–19 April 1997

7
Armchair and Washing Machine with Bobo Mask
1982
armchair, washing machine, acrylic paint
height c.118 in / c.300 cm, width variable

Provenance
The artist

Exhibited
'Bill Woodrow', Galerie 't Venster, Rotterdam, 8 October–10 November 1982 (ex-catalogue)

'Objects & Figures: New Sculpture in Britain', Scottish Arts Council exhibition, Fruitmarket Gallery, Edinburgh, 20 November 1982–8 January 1983

'Figures and Objects: Recent Developments in British Sculpture', John Hansard Gallery, The University, Southampton, 8 February–12 March 1983 (listed in catalogue; not repro.)

'Bill Woodrow: Beaver, Bomb and Fossil', Museum of Modern Art, Oxford, 29 May–31 July 1983, catalogue no.15 (not repro.)

'British Sculpture Since 1965: Cragg, Deacon, Flanagan, Long, Nash, Woodrow', Museum of Contemporary Art, Chicago, 23 January–5 April 1987; touring to San Francisco Museum of Modern Art, 4 June–26 July 1987; Newport Harbor Art Museum, Newport Beach, California, 14 August–4 October 1987; Hirshhorn Museum and Sculpture Garden, Washington, D.C., 10 November 1987–10 January 1988; Albright-Knox Art Gallery, Buffalo, New York, 12 February–10 April 1988

'Panic Attack! Art in the Punk Years', Barbican Art Gallery, London, 5 June–9 September 2007 (repro. in colour in catalogue pp.190–191; listed p.215)

'Sculpture', Waddington Galleries, London, 5–30 October 2010 (repro. in colour in catalogue)

Literature

'Objects & Figures', Michael Newman, in *Objects & Figures* (exhibition broadsheet), Fruitmarket Gallery, Edinburgh, 1982

'Bill Woodrow: Objects Reincarnated', Mary Jane Jacob, in *A Quiet Revolution: British Sculpture Since 1965* (exhibition catalogue), Thames and Hudson, London, 1987, published to accompany the exhibition, 'British Sculpture Since 1965', pp.156–162, cit. p.160, catalogue no.47 (repro. in b&w p.168, pl.116)

'The Exploded Image', Ariella Yedgar, in *Panic Attack! Art in the Punk Years* (exhibition catalogue), Barbican Art Gallery, London, in association with Merrell Publishers, 2007, pp.172–177, cit. p.177

8
A Passing Car, a Caring Word
1982
bed base, car door, enamel paint
118 × 78¾ × 102⅜ in / 300 × 200 × 260 cm approx.

Provenance
The artist

Exhibited
'Bill Woodrow: Sculpture', Galerie Michèle Lachowsky, Antwerp, from 2 December 1982

'Bill Woodrow: Sculpture', Museum van Hedendaagse Kunst, Ghent, from 26 March 1983

'The British Art Show: Old Allegiances and New Directions 1979–1984', Arts Council exhibition, City of Birmingham Museum and Art Gallery and Ikon Gallery, Birmingham, 2 November–22 December 1984; touring to Royal Scottish Academy, Edinburgh, 19 January–24 February 1985; Mappin Art Gallery, Sheffield, 16 March–4 May 1985; Southampton Art Gallery, 18 May–30 June 1985, catalogue no.151 (repro. in colour p.71)

'Skulptur. 9 kunstnere fra Storbritannien / Sculpture: 9 Artists from Britain', Louisiana Museum of Modern Art, Humlebæk, Denmark, 1 March–20 April 1986, catalogue no.45 (not repro.)

'British Sculpture Since 1965: Cragg, Deacon, Flanagan, Long, Nash, Woodrow', Museum of Contemporary Art, Chicago, 23 January–5 April 1987; touring to San Francisco Museum of Modern Art, 4 June–26 July 1987; Newport Harbor Art Museum, Newport Beach, California, 14 August–4 October 1987; Hirshhorn Museum and Sculpture Garden, Washington, D.C., 10 November 1987–10 January 1988; Albright-Knox Art Gallery, Buffalo, New York, 12 February–10 April 1988

Literature

'The sculpture of Bill Woodrow', David Elliott, in *Bill Woodrow: Beaver, Bomb and Fossil* (exhibition catalogue), Museum of Modern Art, Oxford, 1983, pp.3–10, cit. p.6 (repro. in b&w p.7)

'Bill Woodrow: Material Truths', Mark Francis, in *Bill Woodrow: soupe du jour* (exhibition catalogue), Musée de Toulon, Toulon, France, 1984 (unpaginated; not repro.)

'Bill Woodrow – materialets sandheder', Mark Francis, *Louisiana Revy*, 26. årgang nr.2, March 1986, pp.46–51, cit. p.50 (not repro.)

'The Elevation of the Host', Lynne Cooke, in *Bill Woodrow: Sculpture 1980–86* (exhibition catalogue), The Fruitmarket Gallery, Edinburgh, 1986, pp.1–11, cit. p.4 (repro. in b&w p.4)

'Bill Woodrow: Objects Reincarnated', Mary Jane Jacob, in *A Quiet Revolution: British Sculpture Since 1965* (exhibition catalogue), Thames and Hudson, London, 1987, published to accompany the exhibition 'British Sculpture Since 1965', pp.156–162, cit. p.160, catalogue no.48 (repro. in colour p.[169], pl.117)

Creators in British Art (Japanese text), Takeshi Sakurai, Keibunsha Ltd, Tokyo, 2004, p.136 (repro. in colour p.108)

9
Humming Bird, Ring and Medal
1982
car door, enamel and acrylic paint
25½ × 35½ × 11 in / 65 × 90 × 28 cm

Provenance
The artist

Exhibited
'Bill Woodrow: Sculpture', Ray Hughes Gallery, Brisbane, 6–20 August 1982

'Skulptur: Prekärer Realismus zwischen Melancholie und Komik', Kunsthalle Wien, Vienna, 15 October 2004–20 February 2005 (repro. in colour in catalogue p.172)

10
Soupe du Jour
1983
saucepan and ladle, enamel paint
11 × 15⅜ × 8⅝ in / 28 × 39 × 22 cm

Provenance
The artist

Exhibited
'A Pierre et Marie [Phase 5]', 36 rue d'Ulm, Paris, from
 29 April 1984 (repro. in colour in catalogue p.79)
'The International Art Show for the End of World Hunger
 (preview)', International Monetary Fund Visitors'
 Centre, Washington, D.C., 14 October–12 November
 1986
'The International Art Show for the End of World Hunger',
 Minnesota Museum of Art, Saint Paul, Minnesota, 13
 September–8 November 1987; touring Europe and
 South America to 1990 (repro. in colour in catalogue
 p.60)
'Barely Made', Norwich Gallery, Norwich, 5 March–19
 April 1997

Literature
'The Elevation of the Host', Lynne Cooke, in *Bill
 Woodrow: Sculpture 1980–86* (exhibition catalogue),
 The Fruitmarket Gallery, Edinburgh, 1986, pp.1–11,
 cit. pp.8 & 86 (repro. in colour p.[87])

11
Tattoo
1983
car door, car panel, cloth
42½ × 110¼ × 96⅛ in / 108 × 280 × 244 cm

Provenance
The artist
Barbara Gladstone Gallery, New York
Private Collection, New York

Exhibited
'Bill Woodrow: Sculpture', Barbara Gladstone Gallery,
 New York, 10 September–6 October 1983
'Salvaged: Altered Everyday Objects', P.S.1, Long Island
 City, New York, January–March 1984
'Space Invaders', Mackenzie Art Gallery, University
 of Regina, Regina, Saskatchewan, Canada, 1
 February–24 March 1985, catalogue no.45 (repro. in
 b&w p.88; listed p.128)

Literature
Winter, P.S.1, The Institute for Art and Urban Resources,
 New York, 1984 (repro.)
Catherine Ferbos (intro.), in *Bill Woodrow: soupe du
 jour* (exhibition catalogue), Musée de Toulon, Toulon,
 France, 1984 (unpaginated; repro. in b&w fig.1)
'Martian poets', *Artics*, no.1, Barcelona, July 1985
 (repro.)
'Natural Produce, An Armed Response', Lynda Forsha,
 in *Natural Produce, An Armed Response: Sculpture by
 Bill Woodrow* (exhibition catalogue), La Jolla Museum
 of Contemporary Art, La Jolla, California, 1985, pp.6–
 16, cit. p.8 (not repro.)
'The Elevation of the Host', Lynne Cooke, in *Bill
 Woodrow: Sculpture 1980–86* (exhibition catalogue),
 The Fruitmarket Gallery, Edinburgh, 1986, pp.1–11,
 cit. pp.6, 7 & 66 (repro. in colour p.[67])

12
Ship of Fools, Figure of Gold
1984
car bonnet, chrome stand, enamel paint
67 × 46½ × 55 in / 170 × 118 × 140 cm

Provenance
The artist
Lisson Gallery, London
Private Collection, Germany
New Art Centre Sculpture Park & Gallery, Roche Court

Exhibited
New Art Centre Sculpture Park & Gallery, Roche Court,
 East Winterslow, Salisbury, 2004

Literature
Bill Woodrow (exhibition catalogue), Jean-Christophe
 Ammann (intro.), Kunsthalle Basel, Basel, 1985, p.16
 (repro. in colour p.17)
Bill Woodrow: Sculpture 1980–86 (exhibition catalogue),
 Lynne Cooke (intro.), The Fruitmarket Gallery,
 Edinburgh, 1986, p.98 (repro. in colour p.99])
'Bill Woodrow: The Ship of Fools', Lynne Cooke, in
 PARKETT, no.12, Zurich, March 1987, pp.6–11
 (English text) & pp.12–17 (German text) (repro. in
 b&w p.17)
'Bill Woodrow: Objects Reincarnated', Mary Jane Jacob,
 in *A Quiet Revolution: British Sculpture Since 1965*
 (exhibition catalogue), Thames and Hudson, London,
 1987, pp.156–162, ref. p.162
Bill Woodrow, Waddington Galleries, London, 2005
 (repro. in colour p.[19])

13
Flageolet Plate
1984
telephone relay box, enamel paint
39⅜ × 15¾ × 15¾ in / 100 × 40 × 40 cm

Provenance
The artist

Literature
Bill Woodrow (exhibition catalogue), Jean-Christophe
Ammann (intro.), Kunsthalle Basel, Basel, 1985, p.26
(repro. in colour p.27)
*Entre el Objeto y la Imágen: Escultura británica
contemporánea* (exhibition catalogue), Lewis Biggs
and Juan Muños, The British Council / Ministerio de
Cultura, Madrid, 1986 (repro. in b&w p.[179]; listed
p.180)

14
Sunset
1984
car bonnet, wooden table, enamel paint
68½ × 51 × 25½ in / 174 × 130 × 65 cm

Provenance
The artist

Exhibited
'Armed', Interim Art, London, 12 October–1 December
1985
'Bill Woodrow: Sculpture', Butler Gallery, Kilkenny,
Ireland, 23 August–14 September 1986
'Current Affairs: British Painting and Sculpture in the
1980s', organised in collaboration with The British
Council, Museum of Modern Art, Oxford, 1–29 March
1987; touring to Mücsarnok, Budapest, 24 April–31
May 1987; Národni Galerie, Prague, 19 June–7 August
1987; Zacheta, Warsaw, 14 September–31 October
1987, catalogue no.55, p.27 (repro. in colour)
'Vom Kriege', Grazer Kunstverein, Graz, Austria,
17 October–6 November 1989
'Skulptur Heute', Galerie Heinz Holtmann, Cologne,
19 March–8 May 1993

'What happens if…?', Storey Gallery, Lancaster,
30 January–3 April 2010

Literature
Bill Woodrow (exhibition catalogue), Jean-Christophe
Ammann (intro.), Kunsthalle Basel, Basel, 1985, p.34
(repro. in colour p.35)
*Entre el Objeto y la Imágen: Escultura británica
contemporánea* (exhibition catalogue), Lewis Biggs
and Juan Muños, The British Council / Ministerio de
Cultura, Madrid, 1986 (repro. in b&w p.[178]; listed
p.180)
'The Elevation of the Host', Lynne Cooke, in *Bill
Woodrow: Sculpture 1980–86* (exhibition catalogue),
The Fruitmarket Gallery, Edinburgh, 1986, pp.1–11,
cit. pp.8 & 100 (repro. in colour p.[101])
Bill Woodrow (exhibition booklet), Butler Gallery,
Kilkenny, Ireland, 1986 (repro.)
British Object Sculptors of the '80s I, Marco Livingstone,
ArT RANDOM, Kyoto Shoin International Co. Ltd.,
Kyoto, Japan, 1989 (repro. in colour)

15
Closet
1985
metal locker, enamel paint
69 × 27 × 55½ in / 175 × 69 × 141 cm

Provenance
The artist

Exhibited
'Currents', The Institute of Contemporary Art, Boston,
from 18 September 1985

Literature
'Die Veredelung des 'Wirts'', Lynne Cooke, in *Bill
Woodrow: Positive Earth, Negative Earth* (exhibition
catalogue), Kunstverein München, Munich, 1987
(repro.)

16
Hammer On
1987
metal suitcase, enamel paint
46½ × 18 × 10¼ in / 118 × 46 × 26 cm

Provenance
The artist

Exhibited
'British Now: sculpture et autres dessins', Musée d'art
contemporain de Montréal, Montreal, 21 September
1988–8 January 1989, catalogue p.71 (not repro.)

17
Silent Running
1987
ventilation ducting, desk trays, wooden barrel, enamel paint
51½ × 42 × 27 in / 131 × 107 × 69 cm

Provenance
The artist

Exhibited
'Bill Woodrow: Sculpture', Barbara Gladstone Gallery,
New York, 21 November–23 December 1987
'Escultura Británica Contemporánea: De Henry Moore
a los años 90 / Contemporary British Sculpture:
From Henry Moore to the 90s', Auditorio de Galicia,
Santiago de Compostela, Spain, 10 June–30 July
1995; touring to Fundação de Serralves, Oporto,
Portugal, 7 September–5 November 1995 (repro. in
colour in catalogue p.125)

Literature
'La metafisica dell'oggetto. Bill Woodrow', Demetrio
Paparoni in conversation with Bill Woodrow, *Tema
Celeste*, no.15, Siracusa, Italy, March–May 1987

18
Half King, Whole Fish
1988
car bonnet, steel locker, metal hat box, aluminium ladder,
chair, enamel paint
87 × 55 × 30¾ in / 221 × 140 × 78 cm

Provenance
The artist

19
Madagascar
1987
carpet, metal locker, acrylic paint
118 × 149⅝ × 10 in / 300 × 380 × 25 cm

Provenance
The artist

Exhibited
'Bill Woodrow: Sculpture', Lisson Gallery, London,
 27 May–20 June 1987

1948
Born near Henley, Oxfordshire

1967–68
Winchester School of Art, Winchester

1968–71
St Martin's School of Art, London

1971–72
Chelsea School of Art, London

1982
Represented Britain at the Sydney and Paris Biennale

1983
Represented Britain at the São Paulo Bienal

1985
Represented Britain at the Paris Biennale

1986
Finalist Turner Prize, Tate Gallery, London

1988
Winner Anne Gerber Award, Seattle Art Museum, Seattle

1991
Represented Britain at the São Paulo Bienal

1996–2001
Trustee of the Tate Galleries

2000–2001
Regardless of History, Fourth Plinth, Trafalgar Square,
 London

2002
Elected Member of the Royal Academy of Arts, London

2003–2008
Governor of the University of the Arts, London

2003–2011
Trustee of the Imperial War Museum, London

2007
Selector for the Summer Exhibition at the Royal Academy
 of Arts, London, with Ian Ritchie and Paul Huxley

Lives and works in London and Hampshire

1972
Whitechapel Art Gallery, London

1979
Kunstlerhaus, Hamburg

1980
The Gallery, Acre Lane, London

1981
L.Y.C. Gallery, Banks, Cumbria
New 57 Gallery, Edinburgh
Galerie Wittenbrink, Regensburg, Germany

1982
Lisson Gallery, London
Kunstausstellungen, Stuttgart
Galerie Eric Fabre, Paris
St. Paul's Gallery, Leeds
Ray Hughes Gallery, Brisbane
Galerie 't Venster, Rotterdam
Galerie Lachowsky, Antwerp

1983
Galleria Toselli, Milan
Museum van Hedendaagse Kunst, Ghent
Lisson Gallery, London
Museum of Modern Art, Oxford
Barbara Gladstone Gallery, New York
Locus Solus, Genoa
art and project, Amsterdam

1984
Mercer Union, Toronto
Musée de Toulon, Toulon
Paul Maenz, Cologne

1985
Kunsthalle Basel, Basel
Barbara Gladstone Gallery, New York
Donald Young Gallery, Chicago
La Jolla Museum of Contemporary Art, La Jolla, California
I.C.A., Boston
Matrix, University Art Museum, University of California, Berkeley

1986
Galerie Nordenhake, Malmo
Paul Maenz, Cologne
Butler Gallery, Kilkenny
Fruitmarket Gallery, Edinburgh
Installation for the Mattress Factory, Pittsburgh

1987
Kunstverein, Munich
Lisson Gallery, London
Cornerhouse, Manchester
Barbara Gladstone Gallery, New York

1988
Paul Maenz, Cologne
Seattle Art Museum, Seattle
Christmas Tree, Tate Gallery, London

1989
Musée des Beaux-Arts, Le Havre; touring to Musée des Beaux-Arts, Calais
Galerie Nordenhake, Stockholm
Mala Galerija, Moderna Galerija, Ljubljana
Fred Hoffman Gallery, Los Angeles
Saatchi Collection, London
Imperial War Museum, London

1990
Galerie Fahnemann, Berlin

1991
XXI São Paulo Bienal, Brazil
Galleria Locus Solus, Genoa
Galerie für Druckgrafik, Zurich

1992
Galerie Sabine Wachters, Brussels and Knokke

1993
Quint Krichman Projects, La Jolla, California (drawings)
Chisenhale Gallery, London; touring to Aspex Gallery, Portsmouth (with Richard Deacon)

1994
Galerie Sabine Wachters, Brussels (with Richard Deacon)
Model Arts Centre, Sligo; touring to Limerick City Gallery of Art, Limerick
Galerie Sabine Wachters, Brussels and Knokke (drawings)
Musée Ianchelevici, La Louvière, Belgium

1995
Oriel, Cardiff
Camden Arts Centre, London (drawings); touring to Harris Museum and Art Gallery, Preston

1996
Duveen Galleries, Tate Gallery, London; touring to Institut Mathildenhöhe, Darmstadt, Germany
Ormeau Baths Gallery, Belfast (drawings)

1997
Butler Gallery, Kilkenny (drawings)
Mestna Galerija, Ljubljana
Galerie Sabine Wachters, Brussels

1998
Galerie Sabine Wachters, Brussels (drawings)
British Library, London (permanent)

1999
Lothbury Gallery, London

2000
New Art Centre Sculpture Park and Gallery, Roche Court, Salisbury
Fourth Plinth, Trafalgar Square, London

2000–2001
Monographic Room, Tate Modern, London

2001
Midsummer Place, Milton Keynes (permanent)
South London Gallery, London; touring to Mappin Art Gallery, Sheffield

2002
Glynn Vivian Art Gallery, Swansea

2004
New Art Centre Sculpture Park and Gallery, Roche Court, Salisbury; touring to Palácio Nacional de Queluz, Lisbon (with Richard Deacon)

2005
Yorkshire Sculpture Park (with Richard Deacon)
Snape Maltings, Snape, Suffolk
Hammersmith Hospital, London (permanent)

2006
Waddington Galleries, London

2007
Plymouth City Museum and Art Gallery, Plymouth; touring to Chateau Musée, Dieppe (with Richard Deacon)
Sabine Wachters Fine Arts, Knokke
Winchester Great Hall, Winchester

2008
Pier Arts Centre, Stromness, Orkney (with Richard Deacon)
Lullin + Ferrari, Zurich
Bloomberg SPACE London, London (with Richard Deacon)

2009
Sabine Wachters Fine Arts, Knokke

SELECTED GROUP EXHIBITIONS

1971
Art Systema, Museo de Arte Moderno, Buenos Aires

1972
Art as an Idea in England, C.A.Y.C, Buenos Aires
3rd Biennale of Columbia, Bogota
Platform 72, Museum of Modern Art, Oxford
Drawing, Museum of Modern Art, Oxford
An International Show of Fourteen New Artists, Lisson Gallery, London

1981
Objects and Sculpture, Arnolfini, Bristol, and I.C.A., London
The Motor Show, The Front Room, Percy Road, London
Through the Summer, Lisson Gallery, London
British Sculpture in the 20th Century, Whitechapel Art Gallery, London

1982
Biennale of Sydney, Sydney
South Bank Show, South London Art Gallery, London
Neue Skulptur, Galerie nächst St. Stephan, Vienna
Leçons de Choses, Kunsthalle, Bern, Switzerland; touring to Musées d'Art et d'Histoire, Chambéry and Maison de la Culture, Chalon-sur-Saône, France
Aperto 82, Biennale di Venezia, Venice
Englische Plastik Heute, Kunstmuseum, Lucerne, Switzerland
XII Biennale of Paris, Paris
Prefiguration, Chambéry, France
London/New York, Lisson Gallery, London
Objects & Figures, Fruitmarket Gallery, Edinburgh
Vol de Nuit, Galerie Eric Fabre, Paris

1983
Tema Celeste, Museo Civico d'Arte Contemporanea, Gibellina, Italy
La Trottola de Sirio, Centro d'Arte Contemporanea, Siracusa, Italy
A Pierre et Marie (Phase 1), 36 rue d'Ulm, Paris
Truc et Troc, ARC Musée d'Art Moderne de la Ville de Paris, Paris
Figures and Objects, John Hansard Gallery, Southampton
La Grande Absente, Musée d'Ixelles, Brussels

A Pierre et Marie (Phase 2), 36 rue d'Ulm, Paris
Nécessités, Château de la Roche Jagu, Bretagne, France
Australian Perspecta 1983, Art Gallery of New South Wales, Sydney
Beelden 1983, Rotterdam
Forme e Informe, Bologna
A Pierre et Marie (Phase 3), 36 rue d'Ulm, Paris
Reseau Art 83, Art Prospect, France
The Sculpture Show, Hayward/Serpentine Gallery, London
L'Estate del 1983 fu Straordinariamente Lunga e Fresca: Senza Precedenti, Marciana, Italy
Arcaico Contemporaneo, Museo del Sannio-Benevento, Italy
Best of ..., Le coin du miroir, Dijon, France
New Art at the Tate Gallery, Tate Gallery, London
Costellazione, Galleria Giorgio Persano, Turin
Transformations, XVII Bienal de São Paulo, Museu de Arte Moderna, Rio de Janiero; touring to Museo de Arte Moderno, Mexico City; Fundação Calouste Gulbenkian, Lisbon
As of Now, Walker Art Gallery, Liverpool; touring to Douglas Hyde Gallery, Dublin
Skulptur Heute 1, Galerie Joellenbeck/Galerie Wintersberger, Cologne
La Imagen del Animal, Madrid

1984
A Pierre et Marie (Phase 5), 36 rue d'Ulm, Paris
Salvaged, P.S.1., New York
An International Survey of Recent Painting and Sculpture, Museum of Modern Art, New York
Skultur im 20. Jahrhundert, Merian Park, Basel
Contemporary Acquisitions, Imperial War Museum, London
Nuit et Jour, Salle Gatier et Cave des Sources, Boen, France
Terrae Motus 1, Fondazione Amelio, Ercolano, Naples
Home and Abroad, Serpentine Gallery, London
Through the Summer 1984, Lisson Gallery, London
ROSC '84, The Guinness Hop Store, Dublin
Biennale van de Kritiek 1984, Antwerp
Sculptures dans L'Usine, Comité d'Etablissement Renault Sandouville; touring to Musée des Beaux-Art Andre Malraux, Le Havre, France

The British Art Show, City Museum and Art Gallery, Ikon Gallery, Birmingham; touring to Royal Scottish Academy, Edinburgh; Mappin Art Gallery, Sheffield; Southampton Art Gallery
Armed, Interim Art, London
Deux Regions en France: L'Art International D'Aujourd' Hui, Palais des Beaux-Arts, Charleroi, Belgium
Opere su Carta 1984, Centro d'Arte Contemporanea, Siracusa, Italy
A Pierre et Marie (Phase 7), 36 rue d'Ulm, Paris

1985
Space Invaders, Mackenzie Art Gallery, Regina; touring throughout Canada
Images of War, Chapter, Cardiff
One City a Patron, Collins Gallery, Glasgow; touring throughout Scotland
The British Show, Art Gallery of Western Australia, Perth; touring to Art Gallery of New South Wales, Sydney; Queensland Art Gallery, Brisbane; Royal Exhibition Building, Melbourne; National Gallery of Art, Wellington, New Zealand
7000 Eichen, Kunsthalle, Tübingen, Germany
Sculptures du Frac Rhône-Alpes, Musée Sainte Croix, Poiters, France; touring throughout France
Nouvelle Biennale de Paris 85, Paris
Drawing: Painting and Sculpture, Brooke Alexander Inc., New York
Recent Acquisitions, Moderna Museet, Stockholm
Social Studies, Barbara Gladstone Gallery, New York
Anniottanta, Assessorato alla Cultura del Comune di Ravenna, Italy; touring to Bologna, Imola, Romagna, Italy
Attitudes, Central Gallery, Northampton
Sculptures, Fondation Cartier, Paris
The Irresistible Object: Still Life 1600–1985, Leeds City Art Galleries, Leeds
1985 Carnegie International, Museum of Art, Pittsburgh

1986

Entre el Objeto y la Imágen, Palacio de Velázquez, Madrid; touring to Centre Cultural de la Caixa de Pensions, Barcelona; Bilbao

Sculpture: 9 Artists from Britain, Louisiana Museum, Humlebæk, Denmark

Scultura da Camera, Gipsoteca del Castello Svevo, Bari, Italy

Choix d' Oeuvres de la Collection, FRAC Bourgogne, Dijon, France

Modern Art? It's a Joke!, Cleveland Gallery, Middlesbrough

Englische Bildhauer, Galerie Harald Behm, Hamburg

Painting and Sculpture Today, Indianapolis Museum of Art, Indianapolis

Recent Sculpture, BlumHelman, New York

American/European Painting and Sculpture 1986, L.A. Louver, Venice, California

The International Art Show for the End of World Hunger (preview), International Monetary Fund Visitors' Centre, Washington, D.C.

Uno Sguardo, Magasin, Grenoble; touring to Accademia di Belle Arti, Naples

The Turner Prize, Finalists Exhibition, Tate Gallery, London

No Place like Home, Cornerhouse, Manchester

Dedoublements, Theatre de la Presle, Romans, France

Il Cangiante, Padiglione d'Arte Contemporanea, Milan

1987

British Sculpture since 1965, Museum of Contemporary Art, Chicago; touring to Peace Museum, Chicago; San Francisco Museum of Art; Newport Harbor Art Museum, Newport Beach, California; Hirshhorn Museum and Sculpture Garden, Washington, D.C.; Albright-Knox Art Gallery, Buffalo, New York

Conversations, Darlington Arts Centre; touring throughout England

Current Affairs, Museum of Modern Art, Oxford; touring to Mücsarnok, Budapest; Národni Galerie, Prague; Zacheta, Warsaw

Terrae Motus, Grand Palais, Paris

British Art of the 1980s, Liljevalchs Konsthall, Stockholm; touring to Sara Hilden Art Museum, Tampere, Finland

Art Against Aids, Barbara Gladstone Gallery, New York (with Richard Deacon)

Juxtapositions, P.S.1, New York

Manierismus Subjektiv, Galerie Krizinger, Vienna

Een Keuze, KunstRAI 87, Amsterdam

Documenta 8, Kassel, Germany

20th Anniversary Exhibition, Lisson Gallery, London

Vessel, Serpentine Gallery, London

Contemporary Assemblage, Germans Van Eck, New York

The International Art Show for the End of World Hunger, Minnesota Museum of Art, Saint Paul, Minnesota; touring throughout Europe and South America until 1990

State of the Nation, Herbert Art Gallery, Coventry

Documenta Auslese 87, A 11 Art Forum Thomas, Munich

1988

Graven Images, Harris Museum and Art Gallery, Preston

Starlit Waters, Tate Gallery, Liverpool

Visages, Musée St. George, Liège, Belgium

Object and Image, City Museum and Art Gallery, Stoke-on-Trent

A Personal Choice, Nigel Greenwood Gallery, London

Modern British Sculpture from the Collection, Tate Gallery, Liverpool

British Now: Sculpture et Autres Dessins, Musée d'Art Contemporain de Montréal, Montreal

Britannica, Ecole d'Architecture de Normandie, Rouen; touring to Museum van Hedendaagse Kunst, Antwerp; Centre d'Art Contemporain Midi-Pyrenees, Toulouse

Porkkana – Kokoelma, Vanhan Galleria, Helsinki

That which Appears is Good; That which is Good Appears, Tanja Grunert, Cologne

1989

Mote I Nord, Kunsternes Hus, Oslo

It's a Still Life, City Museum and Art Gallery, Plymouth; touring throughout UK

Mondi Possibli, Le Case d'Arte, Milan

Oeuvres du Fonds Regional d'Art Contemporaine de Bourgogne, APAC Centre d'Art, Nevers Banlay, France

Kunst und Heizung, Messe, Frankfurt

Collection du Frac Bourgogne, Musée des Beaux Arts, La Chaux de Fonds, Switzerland

The Tree of Life, Cornerhouse, Manchester; touring throughout UK

The Thatcher Years, Flowers East, London

Vom Kriege, Grazer Kunstverein, Graz, Austria

Specchi Ustori, Museo Palazzo Bellomo, Siracusa, Italy

Beyond the Everyday Object, MUKHA, Antwerp

1990

Objets, Musée Boucher de Perthes, Abbeville, France

Glasgow's Great British Art Exhibition, McLellan Galleries, Glasgow

Great Britain – USSR, The House of the Artist, Kiev/The Central House of the Artist, Moscow

For a Wider World, Ukranian Museum of Fine Art, Kiev; touring to Musée National d'Art et d'Histoire, Luxembourg; Sofia, Bulgaria; Museo de Bellas Artes, Buenos Aires

Graphik Live, Graphik-Sammlung, Der Eidg. Tech. Hochschule, Zurich

1991

Metamemphis 1991, Galerie Tanit Köln, Cologne

Dessin d'une Collection, Extrait 7, FRAC Picardie, Amiens, France

Metropolis, Martin Gropius Bau, Berlin

Kunst Europa, Kunstverein Konstanz, Konstanz, Germany

La Sculpture Contemporaine après 1970, Fondation Daniel Templon, Musée Temporaire, Frejus, France

Das Goldene Zeitalter, Württembergische Kunstverein, Stuttgart

1992

The New Patrons, Christie's, London

Artistes pour Amnesty International, Hotel des Arts, Paris

Kunstwerken verworven door de Vlaamse Gemeenschap in 1990–1991, Museum van Deinze en de Leiestreek, Deinze, Belgium

BBC Billboard Art Project (in conjunction with Mills and Allen)

A Marked Difference, Arti et Amicitiae, Amsterdam

Le portrait dans l'Art Contemporain, Musée d'Art Moderne et d'Art Contemporain, Nice

Arte Amazonas, Museu de Arte Moderna, Rio de Janiero; touring to Museu de Arte, Brasilia, Brazil; Staatliche Kunsthalle, Berlin; Technische Sammlungen, Dresden; Ludwig Forum für Internationale Kunst, Aachen, Germany

Whitechapel Open, Whitechapel Art Gallery and other venues, London

"As I See Myself" Artists in Their Work, City Museum and Art Gallery, Plymouth

The Cutting Edge, Barbican Art Gallery, London

Innocence and Experience, City Art Gallery, Manchester; touring to Ferens Art Gallery, Hull; Castle Museum, Nottingham; Kelvingrove Art Gallery and Museum, Glasgow

Des Dessins pour les Élèves du Centre entre des deux Thielles, *Les Landeron*, Centre scolaire et sportif des Deux Thielles, Les Landeron/Offentliche Kunstsammlung Basel, Museum fur Gegenwartskunst, Basel

New Voices, Centre de Conferences Albert Borschette, Brussels

Artists of the Gallery, Galerie Sabine Wachters, Brussels and Knokke

Terrae Motus, Reggia di Caserta, Caserta, Italy

Scultori Inglesi: Disegni Di Cragg, Deacon, Houshiary, Kapoor, Woodrow, Galleria Federica Inghilleri, Milan

1993

Declarations of War, Contemporary Art from the Imperial War Museum, Kettle's Yard, Cambridge

Autoportraits Contemporain/Here's Looking at Me, Espace Lyonnais d'Art Contemporain, Lyon

Images from the Coalfields, Angela Flowers Gallery, London

Out of Sight Out of Mind, Lisson Gallery, London

Skulptur Heute, Galerie Heinz Holtmann, Cologne

Recent British Sculpture, Derby Museum and Art Gallery; touring throughout UK

Sculptures Contemporaines Acquisitions Récentes, Musée des Beaux-Arts, Calais

No More Heroes Anymore: Contemporary Art From The Imperial War Museum, Royal Scottish Academy, Edinburgh

Second Sight, Northern Centre for Contemporary Art, Sunderland; touring to Newlyn Orion Gallery, Penzance; Orchard Gallery, Derry

1994

The Fifth International Shoebox Sculpture Exhibition, The University of Hawaii Art Gallery, Honolulu; touring throughout USA and Taiwan to 1996

Dessins et Sculptures, FRAC de Picardie, Amiens, France

Speakers Corner, The Art Bus, touring Fife, Scotland

Back to Basics: a Major Retrospective, Flowers East, London

International Print Triennial '94, Krakow, Poland

Sculpture at Goodwood, The Hat Hill Sculpture Foundation, Goodwood, West Sussex

Contemporary Art Tsurugi '94, Tsurugi, Japan

A Changing World: 50 Years of Sculpture from the British Council Collection, State Russian Museum, St. Petersburg

Terrae Motus, Palazzo Reale, Caserta, Italy

Selections from the Lewitt Collection, Atrium Gallery, University of Connecticut, Storrs, Connecticut

1995

Inter-Kontakt-Graphik Prague '95, Prague

Schyls Donation, Malmö Konsthall, Malmo, Sweden

Contemporary British Art in Print, Scottish National Gallery of Modern Art, Edinburgh; touring to Yale Center for British Art, New Haven, Connecticut

From Picasso to Woodrow: Recently Acquired Prints and Portfolios, Tate Gallery, London

Portable Fabric Shelters, London Printwork Trust, London, The Bradford Gallery, Bradford

Bunker/Mule for Fredsskulptur 1995, Blavand, Jutland, Denmark (Permanent)

Contemporary Art Society Collection, Butler Gallery, Kilkenny

Weltkunst Collection, Irish Museum of Modern Art, Dublin

De Henry Moore a los años 90, Auditorio de Galicia, Santiago de Compostela, Spain; touring to Fundação de Serralves, Oporto, Portugal

Caravanseray of Contemporary Art, Furioso '95, Pescara, Italy

International Biennal of Graphic Art, Ljubljana

Ripple Across the Water, Watari-Um, The Watari Museum of Contemporary Art, Tokyo

Accrochage Pedagogique, FRAC Bourgogne, Dijon, France

Soyons Serieux..., Musée d'Art Moderne, Villeneuve d'Ascq, France

Prints and Drawings: Recent Acquisitions 1991–95, British Museum, London

1996

Take it from Here, Museum and Art Gallery, Sunderland, City Arts Centre and Library and Reg Vardy Gallery, Sunderland

Tate on the Tyne, Laing Art Gallery, Newcastle upon Tyne

Prints, Alan Cristea Gallery, London

Un siècle de sculpture anglaise, Jeu de Paume, Paris

Natur?, Kunst- und Ausstellungshalle der Bundesrepublik Deutschland, Bonn

Contemporary Art from the Museum's Collection, Imperial War Museum, London

Weltkunst Collection: Works on Paper, Ormeau Baths Gallery, Belfast

Portraits d'Objets, Espace Saint-Jacques, Saint-Quentin, Picardie, France

From Figure To Object, Frith Street Gallery and Karsten Schubert Gallery, London

1997

Barely Made, Norwich Gallery, Norwich

Marking Presence, Artsway, Sway, Hampshire

A Ilho do Tesouro, Centro de Arte Moderna Jose de Azeredo Perdigão, Lisbon

Selected Works from the Collection, Irish Museum of Modern Art, Dublin

Works from the Collection, Museum of Contemporary Art, San Diego

Material Culture: The Object in British Art of the 1980's and 1990's, Hayward Gallery, London

Sexta Bienal de la Habana, Havana, Cuba

Community Choice, Southampton City Art Gallery

Sheffield Town Trust Sculpture Competition, Graves Art Gallery, Sheffield

1998
25 Years of Arts Week, Butler Gallery, Kilkenny
The Janet Wolfson de Botton Gift, Tate Gallery, London
2 Sides, American Medallic Sculpture Association, Newburgh, New York; touring to Museum of the American Numismatic Association, Colorado Springs, Colorado
René Magritte and Contemporary Art, Museum voor de Moderne Kunst, Oostende, Belgium
Modern British Art, Tate Gallery, Liverpool
Sculpture for Winchester, Inner Close, Winchester Cathedral, Winchester
A Space Between, Margarete Roeder Gallery, New York
London Calling, Galleria Nazionale d'Arte Moderna, Rome
Artists of the Gallery, Galerie Sabine Wachters, Knokke, Belgium
Fifty Years of British Sculpture, Lothbury Gallery, London
A Labour of Love, Pallant House Gallery, Chichester; touring to Stadtische Kunsthalle, Mannheim, Germany; Kunstverein Hürth, Cologne; Noorbrandts Museum, Hertogenbosch, The Netherlands; Derby Museum and Art Gallery, Derby; Barbican Centre, London
Forjar el Espacio, Centro Atlantico de Arte Moderno, Las Palmas de Gran Canaria; touring to IVAM Centre Julio González, Valencia; Musée des Beaux-Arts et de la Dentelle, Calais
Hope [Sufferance] Press, Sun and Doves, London
Thinking Aloud, Kettle's Yard, Cambridge; touring to Cornerhouse Gallery, Manchester; Camden Arts Centre, London

1999
Separate Messages, Centenary Gallery, Camberwell College of Arts, London
Bankside Browser, St. Christopher's House, London
Le Musée à l'Heure Anglaise, Musée des Beaux-Arts, Valenciennes, France
Spore: Arti Contemporanee nel Transito Epocale, Cassino, Italy
Animal, Musée Bourdelle, Paris
The Equinox, Cairn Gallery, Nailsworth
Size Immaterial, British Museum, London

2000
Bronze, Holland Park, London
Cultural Ties, Jariwala/Westzone Gallery, London
Seven Print Projects from The Paragon Press, Gimpel Fils, London
De Léonard de Vinci à Calder, Machins Machines, Donjon de Vez, France
Das Fünfte Element–Geld oder Kunst, Kunsthalle, Dusseldorf
Global Art Rheinland 2000, Kunsthalle, Dusseldorf
3 Räume–3 Flüsse: Ihr wart ins Wasser eingeschrieben, Packhof, Hann. Münden, Germany
XXVII Fidem 2000 Internationale Medaillenkunst, Berlin/Weimar, Germany

2001
Close Encounters of the Art Kind, V&A Museum, London
Breaking the Mould, Norwich Castle Museum and Art Gallery, Norwich
Field Day: Sculpture from Britain, Taipei Fine Arts Museum, Taipei, Taiwan
Le Cirva a 15 Ans, Hôtel de Castillon, Aix-en-Provence, France
Paper Assets: Collecting Prints and Drawings 1996–2001, British Museum, London
Permanent installation at Yongsan Family Park, Yongsan-Gu, Seoul, Korea

2002
…From Little Acorns…, Early Works by Academicians, Friend's Room, Royal Academy of Arts, London
Blast to Freeze: British Art in the 20th Century, Kunstmuseum Wolfsburg, Germany; touring to Les Abbatoirs, Toulouse, France
About Face, Croydon Clocktower, Croydon
Le Regard de l'Autre, Musée des Beaux-Arts, Rouen
Summer Exhibition 2002, Royal Academy of Arts, London
In Print, Belgrade, Serbia; touring to Yaroslav, Russia; Yekaterinenburg, Russia; St. Petersburg, Russia; Novosibirsk, Russia; Tel Aviv, Israel
Campus Euro(pe) Art, L'université Paris X, Nanterre; touring throughout France
The Darkened World, The Britten Pears Library, Aldeburgh, Suffolk

The Sculpture Park at the Frederik Meijer Gardens, Grand Rapids, Michigan
Thinking Big: 21st Century British Sculpture, Peggy Guggenheim Collection, Venice

2003
Other Criteria, Henry Moore Institute, Leeds
Yesterday begins Tomorrow, Deste Foundation Centre for Contemporary Art, Athens
Peter Blake Sculpture, The London Institute Gallery, London
Sculptures et Dessins, Arsenal, Abbaye Saint-Jean-des-Vignes, Soissons, France
Sculpture: A Spectator Sport?, Bryanston Park, Dorset
Selections from the Chellgren Gift, The Speed Art Museum, Louisville, Kentucky
Summer Exhibition 2003, Royal Academy of Arts, London
Bright Lights, Big City, David Zwirner Gallery, New York
Independence, South London Gallery, London
Glad that Things Don't Talk, Irish Museum of Modern Art, Dublin
Le Cabinet de Jean-Michel Alberola – Le Fait Accompli, FRAC Picardie, Amiens, France
Handmade Readymade, Mackenzie Art Gallery, Regina, Canada
In Print, Ljubljana, Slovenia; touring to Hakodate, Japan; Shikoku Island, Japan
L'État des Choses. L'Objet dans l'Art de 1960 à Aujourd'hui, Musee des Beaux Arts, Nantes, France
A Bigger Splash: Arte Brittanica da Tate, Pavilhão Lucas Nogueira Garcez Oca/Instituto Tomie Ohtake, São Paulo, Brazil
Sculpture at Goodwood, Creative Space, London

2004
Skulptur: Prekärer Realismus zwischen Melancholie und Komik, Kunsthalle Wien, Vienna
Tom Bendhem: Collector, Ben Uri Gallery, London
25 Artists – 25 Drawings, The Drawing Gallery, London
With Hidden Noise, The Henry Moore Institute, Leeds
Out of Place, Galerie Nordenhake, Berlin
Local Matters, Camberwell College of Arts, London
Off the Beaten Track, Longside Gallery, Yorkshire Sculpture Park, Wakefield

Domestic [F]Utility, New Art Centre Sculpture Park and Gallery, Roche Court, Salisbury
Turning Points: 20th Century British Sculpture, Tehran Museum of Contemporary Art, Tehran, Iran
Summer Exhibition 2004, Royal Academy of Arts, London
El Estado de las Cosas. el Objeto en el Arte desde 1960 a Nuestros Dias, Museo de Arte Contemporanea, Vigo, Spain
In Print, Tyler Print Institute, Singapore
Within the landscape, New Art Centre Sculpture Park and Gallery, Roche Court, Salisbury

2005

Drawings and Works on Paper from the IMMA Collection, Irish Museum of Modern Art, Dublin
40 Artists – 40 Drawings, The Drawing Gallery, London
Revelation: Reflecting British Art in the Arts Council Collection, Laing Art Gallery, Newcastle upon Tyne
Raised Awareness, Tate Modern, London
Effervescence, Musée des Beaux-Arts, Angers, France
El Estado de las Cosas. el Objeto en el arte desde 1960 a Nuestros Dias, ARTIUM, Vitoria-Gasteiz, Spain
Summer Exhibition 2005, Royal Academy of Arts, London
In Print: Prints from the Paragon Press, National Gallery, Kuala Lumpur, Malaysia
Arty Dustcarts, Southwark Council, London
In Print, Museum of Fine Art, Taipei; touring to USM ABM-AMRO Art and Culture Centre, Penang, Malaysia

2006

In Focus: Living History, Tate Modern, London
Pairs: 16 Artists/32 Drawings, The Drawing Gallery, London
Eldorado, MUDAM, Luxembourg
How to Improve the World: 60 Years of British Art, Hayward Gallery, London
BOGADH, Presentation Convent Gallery, Carlow, Ireland
Raised Awareness, Watermans, Brentford, London
Domestic Incidents, Tate Modern, London
Summer Exhibition 2006, Royal Academy of Arts, London
Drawing Inspiration, Abbott Hall Art Gallery, Kendal
60, Sixty Years of Sculpture in the Arts Council Collection, Longside Gallery, Yorkshire Sculpture Park, Wakefield
First International Arts Pestival, WWT London Wetland Centre, London
40 Artists – 40 Drawings, City Inn Westminster, London
Raised Awareness, Arts Depot, North Finchley, London

2007

Panic Attack! Art in the Punk Years, Barbican Art Gallery, London
How to Improve the World: 60 Years of British Art, Gas Hall, Birmingham
St Martin's Sculpture Department 1966–71, Tate Britain, London
Summer Exhibition 2007, Royal Academy of Arts, London
Sculpture in the Close, Jesus College, Cambridge
Rummage – Sculptors' Drawings, Winchester Gallery, Winchester
Mapping the Terrain, Mid Pennine Gallery, Burnley
Drawing from Turner, Tate Britain, London
Venice: City of Dreams?, Sotheby's Conduit Street Gallery, London

2008

Alice, son Miroir et ses Merveilles, Musée des Beaux Arts et de la Dentelle, Calais, France
Punk. No One is Innocent, Kunsthalle Wien, Vienna
Prospects and Interiors, Leeds Art Gallery, Leeds
Western, Lycée Henri Vincenot, Louhans, France
British Sculptors' Drawings: Moore to Gormley, British Museum, London

2009

40 Artists – 80 Drawings, The Drawing Gallery, Walford, Shropshire
Drawing 2009 Biennal Fundraiser, The Drawing Room, London
Summer Exhibition 2009, Royal Academy of Arts, London
Extraordinary Days, Oriel Davies Gallery, Newtown, Powys
Art in Public Places, Henry Moore Institute/Leeds Art Gallery, Leeds
Passports: In Viaggio con L'Arte, Padiglione d'Arte contemporanea, Milan

British Council Collection: The Third Dimension, Whitechapel Gallery, London
Birdland, Salisbury Arts Centre, Salisbury
British Surrealism, A Collectors Eye, City Art Gallery, Leeds
Contemporary Prints, The Drawing Gallery, Walford, Shropshire
Im Blick des Sammlers, Museum Würth, Künzelsau, Germany
GSK Contemporary: Earth: Art of a changing world, Royal Academy of Arts, London
Gli Anni 80, Arengario e Serrone della Villa Reale, Monza, Italy
Cubes, Blocs et Autres Espaces, Musée d'Art Contemporain, Montreal
DLA Piper Series: This is Sculpture, Tate Liverpool

2010

The future demands your participation: Contemporary art from the British Council Collection, Minsheng Art Museum, Shanghai
Rock, Paper, Scissors, Bottega Gallery, Kiev
What happens if…?, Storey Gallery, Lancaster
From Floor to Sky, Ambika P3, University of Westminster, London
Abstracção e Figura Humana, Centro de Arte Moderna Jose de Azeredo Perdigão, Lisbon
Sculpture after 1960, Tate Britain, London
Le Meilleur des Mondes, MUDAM, Luxembourg
British Council Collection: Fall Out: War and Conflict, Whitechapel Gallery, London
Summer Exhibition 2010, Royal Academy of Arts, London
Das Fundament der Kunst, Arp Museum Bahnhof Rolandseck, Remagen, Germany
Coquillages et Crustacés, Musée des Beaux-arts, Brest, France
Sculpture, Waddington Galleries, London
New Works, New Art Centre Sculpture Park and Gallery, Roche Court, Salisbury
Sculptors celebrate the legacy of Fred and Lena Meijer, Frederik Meijer Gardens and Sculpture Park, Grand Rapids, USA
Forms of Reason, Lullin + Ferrari, Zurich
BP British Art Displays 1960–2000, Tate Britain, London
DLA Piper Series: This is Sculpture, Tate Liverpool

2011
Modern British Sculpture, Royal Academy of Arts,
London

Art Gallery of Hamilton, Hamilton, Canada
Arts Council of England
Auckland City Art Gallery, Auckland
British Council
British Library, London
British Museum, London
Butler Gallery, Kilkenny
Cecil Higgins Art Gallery and Museum, Bedford
City Art Gallery, Auckland
FRAC Bourgogne, Dijon, France
FRAC Haute-Normandie, France
FRAC Picardie, Amiens, France
FRAC Rhône-Alpes, Lyon, France
Fundação Calouste Gulbenkian, Lisbon
Government Art Collection
Henry Moore Institute, Leeds
Hirshhorn Museum and Sculpture Garden, Washington,
 D.C.
IMMA - Irish Museum of Modern Art, Dublin
Imperial War Museum, London
Indianapolis Museum, Indianapolis
Kunsthaus Zürich, Zurich
Leeds City Art Galleries, Leeds
Leamington Spa Art Gallery and Museum, Leamington
 Spa
Mackenzie Art Gallery, Regina, Canada
Malmö Konsthall, Malmo, Sweden
Metropolitan Museum of Art, New York
Moderna Museet, Stockholm
MUDAM, Luxembourg
Musée d'Art Contemporain, Montreal
Musée d'Art et d'Histoire, Chambéry, France
Musée des Beaux-Arts, Calais
Musée de Toulon, France
Musées de Ville d'Angers, France
Museo Tamayo, Mexico City
Museum Boymans van Beuningen, Rotterdam
Museum of Art, Carnegie Institute, Pittsburgh
Museum of Contemporary Art, Chicago
Museum of Contemporary Art, San Diego
Museum of Modern Art, New York
Museum van Hedendaagse Kunst, Antwerp
National Gallery of Canada, Ottawa
National Gallery of Contemporary Art, Oslo
Pallant House Gallery, Chichester

Rijksmuseum Kröller-Müller, Otterlo, The Netherlands
Scottish National Gallery of Modern Art, Edinburgh
Southampton Art Gallery, Southampton
Tate, London
The Speed Art Museum, Louisville, Kentucky
University of Warwick, Warwick
Victoria & Albert Museum, London
Yongsan Family Park, Yongsan-Gu, Seoul, Korea

For bibliographical information, please refer to
http://www.billwoodrow.com

Waddington Custot Galleries would like to thank Julia
Kelly for her introductory essay and Bill Woodrow for his
help in organising this exhibition.

BILL WOODROW
SCULPTURES 1981–1988

23 March–16 April 2011

Waddington Custot Galleries
11 Cork Street
London
W1S 3LT

Telephone + 44 20 7851 2200
Facsimile + 44 20 7734 4146
www.waddingtoncustot.com
mail@waddingtoncustot.com

Monday–Friday 10am–6pm
Saturday 10am–1.30pm

All photography of artwork by Bill Woodrow
photographed by Bill Woodrow, except:
cat. no.2, photography by Edward Woodman,
London
cat. nos.3, 4, 6, 7, 8, 10 and 12 photography
by Prudence Cuming Associates, London

Designed by www.hoopdesign.co.uk
Printed by www.fandg.co.uk

Published by Waddington Custot Galleries
Co-ordinated by Louise Shorr

Cover: *Car Door, Armchair and Incident*, 1981
(cat. no.5)
Inside detail p.2: *Ship of Fools, Figure of Gold*
1984 (cat. no.12)

ISBN 978-0-9566174-1-5